IMAGES of America
COAL CAMPS OF SWEETWATER COUNTY

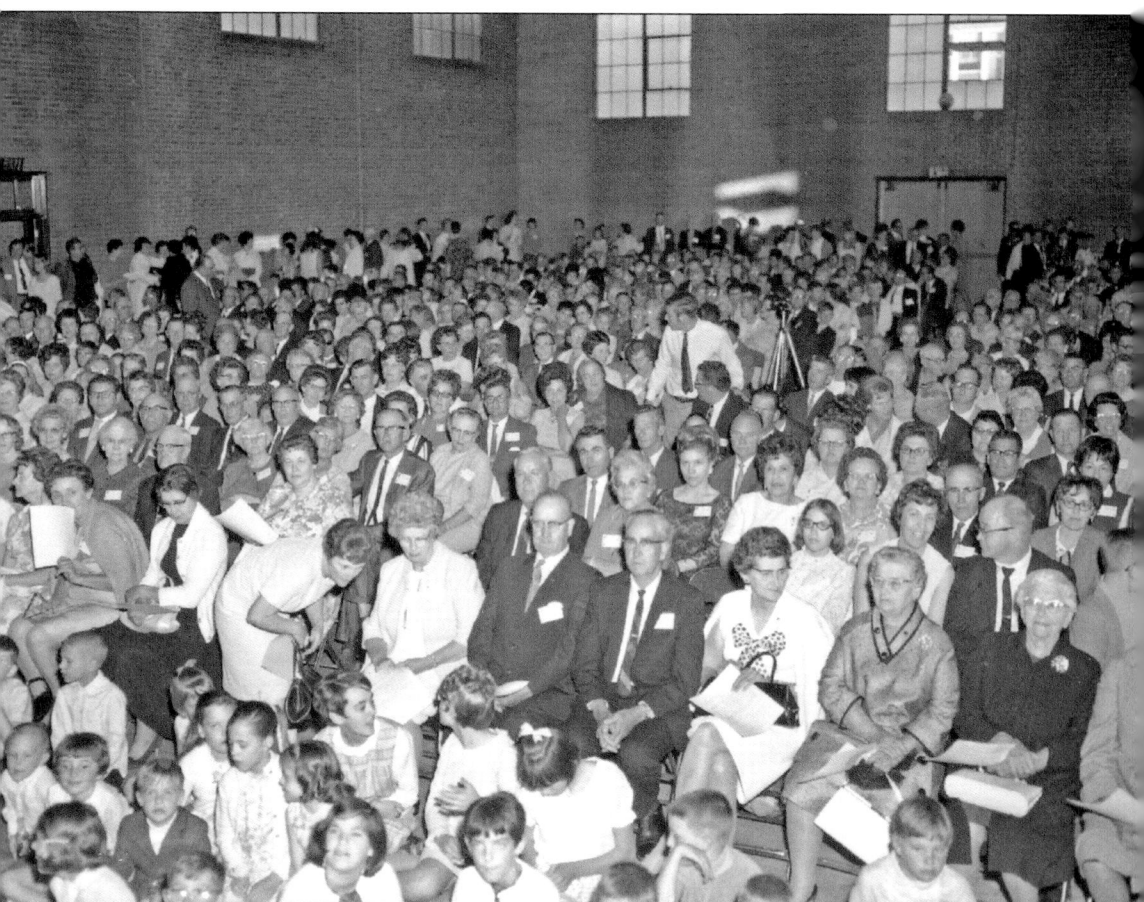

First Coal Camp Reunion. In 1969, more than 1,600 people from all over the United States returned to their former homes to attend the first Coal Camp Reunion. Reuniting residents and miners from the coal camps of Dines, Reliance, Stansbury, and Winton, the three-day reunion featured music, displays, good food, and nonstop conversation. Chairman Kaiser Elich, along with a committee from all of the coal camps and support from the community, created a memorable occasion. (Courtesy of the Coal Camp Reunion collection.)

On the Cover. In 1910, the Union Pacific Coal Company (UPCC) No. 1 mine was dug seven miles north of Rock Springs. The coal camp that developed near it was named Reliance. Mine office employees stand outside the UPCC mine office, located on the left side of the main company building, which was in the middle of camp. The sign in the window told miners that they would "work to-morrow." (Courtesy of the Sweetwater County Historical Museum.)

IMAGES of America
COAL CAMPS OF SWEETWATER COUNTY

Karen Spence McLean and Marjane Telck

Copyright © 2012 by Karen Spence McLean and Marjane Telck
ISBN 978-0-7385-9306-7

Published by Arcadia Publishing
Charleston, South Carolina

Printed in the United States of America

Library of Congress Control Number: 2011936593

For all general information, please contact Arcadia Publishing:
Telephone 843-853-2070
Fax 843-853-0044
E-mail sales@arcadiapublishing.com
For customer service and orders:
Toll-Free 1-888-313-2665

Visit us on the Internet at www.arcadiapublishing.com

The Union Pacific Coal Company built the mines, but the immigrant miners and their families, seeking a better life, built the coal camps. This remarkably diverse group of people mined the unforgiving high desert of Southwestern Wyoming, creating communities, friendships, and opportunities that will long outlive the seam of coal.

CONTENTS

Acknowledgments		6
Introduction		7
1.	Reliance: A Camp That Earned Its Name	9
2.	Winton: A True Melting Pot	37
3.	Dines: A Colony Coal Company Camp	73
4.	Stansbury: The New Mine on the Block	93
5.	Reliance High School: The Ties That Bind	111

Acknowledgments

As descendents of families who lived and worked in the coal camps of Southwestern Wyoming, our goal is to preserve the history of these coal-mining communities. With that in mind, we have attempted to research, gather photographs, document oral histories, plan for reunions, and record as much information as possible. This book has given us the opportunity to share a fragment of that research with future generations. Taking on such a project would not be possible without help from a number of resources.

Ruth Lauritzen and Cyndi McCullers, of the Sweetwater County Historical Museum, were invaluable in helping us obtain pictures. Western Wyoming College and Dudley Gardner shared the Union Pacific Coal Company (UPCC) collection with us, and Teresa Schafe provided scanning assistance. The Wyoming State Archives provided research and pictures. Bob Nelson and the staff of the Rock Springs Historical Museum also offered assistance.

We especially thank all of the former coal camp people who graciously shared their family photographs and stories, including Diane Ainscough, Gary Allen, the Archuleta family, Frances Jean Korogi Brown, Audrey Brunner Caller, Joe Caller, Margo Zakovich Clark, Cipy Cordova, the Hugh Crouch family, Lynn Martin Ernst, the Frank Franch family, Jonelle Bozner Hafner, Maxine Menapace Jereb, Mickey Kaul, Charlene Menapace Kershisnik, the Kovach family, Jack Krmpotich, John Maffoni, the Menghini family, Brenda Durnil McInnis, John Nelson, Ray Overy, Ray Pecolar, Lillian Palcher Pryich, Jim Rafferty, Paul Reuter, Anne Yovich Robertson, Joe Rogers, Melvin Sharp, Alex and George Spence, the Andrew Spence family, the John Tarufelli family, the Henry W. Telck family, Carmen Stephens Thomas, Gloria Tomich, Spiro Varras, the Lawrence Welsh family, and the A.D. Williamson family. Unless otherwise noted, all the photographs in this book are from the Sweetwater County Historical Museum (SCHM) or the Coal Camp Reunion collection (CCR).

A special thanks goes to Helen Chadey, who was an invaluable part of this project. From the inception of the idea for the book, she has provided encouragement, guidance, and assistance. She also shared many pictures from the collection of her late husband, Henry F. Chadey.

We extend our sincere appreciation to everyone who shared in our journey.

INTRODUCTION

In the late 1800s, the Union Pacific Railroad and the population of the United States were pushing westward, a movement that was consecrated in 1869 with the completion of the transcontinental railroad. The growing railroad and population were hungry for coal—a primary source of power. To meet this demand, the Union Pacific and the leaders of the United States looked westward for adequate supplies of available coal. This led UPCC officials and investors to the coalfields of Southwestern Wyoming, where readily accessible deposits of coal lined the hills and valleys adjacent to the new railroad.

Between the 1900s and the 1950s, the coal camps of Reliance, Winton (Megeath), Dines, and Stansbury evolved out of hillsides and desert in Southwestern Wyoming. Most of the inhabitants were immigrants seeking opportunity for themselves and their families. They came from foreign homelands, leaving extended families, milder climates, vegetation, water, and established communities. In Wyoming, they were faced with inclement weather, isolation, poor living conditions, and danger in the mines. The complexion of those who lived and worked in the camps was diverse—different races, religions, and customs—yet they melded into a unique new culture. Spontaneously, they forged a community. Although each camp was isolated and had its own identity, they were connected by the children, the mines, the Union Pacific and Colony Coal Companies, and School District No. 7, which unified the camps and provided the educational foundation for their children.

The shared memories of the "camp people" of Southwestern Wyoming have been repeated from generation to generation. After just a mention of Winton, someone can relate stories about the UPCC store, Bill Russell and the Pool Hall, the path to school, waiting at the Western Café for a ride back to camp after a show or dance, the Show Hall (where residents enjoyed programs and dances), or a picnic at the Winton Cedars or White Rock.

Social activities were a highlight for Reliance—the community bands, the Church of Jesus Christ of Latter-day Saints (LDS) Primary and Relief Society, and baseball teams. The dances and silent movies at the Bungalow and Otto Canestrini and the Pool Hall were also fond recollections for Reliance residents.

Stansbury, the newest of the UPCC camps, worked quickly to establish a community, and residents boasted of their new, modern homes. Women became involved in homemaker groups and card parties. The Cummings family hosted many social activities at the boardinghouse, and residents enjoyed dances and school plays. Walking the short cut to Reliance or to Red Rock for a picnic was a fun experience.

Dines, separated by a hill into North and South Dines, was not a UPCC camp—it was owned by Colony Coal Company. Early residents recall poor living conditions—house walls so thin that the cold Wyoming air poured right through and well water that was "wet, but not so good tasting." As Dines became a community, the recreational hall became the center for movies, dances, card parties, and school programs. Dines youngsters attended their own elementary school, but high school students rode the early morning bus to Reliance.

There were many universal experiences in the camps. Even though the "bosses'" houses had indoor plumbing, almost everyone had the experience of using an outhouse or bathing at the miners' bathhouse. Bringing in coal and wood to fuel the stoves was a daily chore. In winter, women faced the problem of washing clothes, hanging them on lines until they were frozen stiff, and bringing them in to "thaw," creating a steamy house. Women also had the daily chore of making lunch buckets and family meals from home-cooked items. Gardening contests—an attempt by the UPCC to beautify the camps—resulted in a plethora of wonderful yards and gardens and very competitive gardeners.

No family in any camp could forget the terror felt when the mine whistle blew, fearing that a mine accident might have occurred. Camp residents looked forward to Eight-Hour Days, Old Timers' celebrations, First Aid Contests, and parades sponsored by the UPCC. Great rivalries existed to win a coveted prize. Miners' vacations were eagerly anticipated; some families traveled to former homes, but most went "up north" to enjoy fishing and camping. Campfire-roasted potatoes, wild meat, a fresh trout, or a sage chicken were unforgettable delicacies. Everyone loved to dance and did so often. Children danced with parents, and women danced together when partners were unavailable—the polka, an imported dance, was always a favorite. The community councils and unions sponsored most of the camp activities, including dances, parades, and programs. Christmas parties at the community halls, where the children received a sack of candy and a coin, were always a highlight; no child went without something at Christmas!

Education was important to these communities. Teachers were respected, and all children had an opportunity to learn and excel. Reliance High School (RHS) unified the camps through its athletic and school programs. The RHS Pirates were a source of pride within the camps. When the 1946 RHS basketball team beat Rock Springs for the first time, school was cancelled the next day. And when the 1949 "dream team" almost beat Casper for the state championship, a huge contingent of students and parents traveled to the game. Parents also supported drama and musical events. These were unforgettable moments in the communities. The achievements of the educational process and parental support were evident as the camp schools produced doctors, teachers, engineers, lawyers, legislators, and many other successful adults. Few fathers wanted their sons to join them underground.

The religious education of the coal camp communities was not ignored either. Protestant Sunday school classes were offered in the various camps, as well as the LDS Primary and Relief Society. Mass and catechism were held at St. Ann's Church in Winton.

While these communities shared many joys, they also bore the sorrow of losing their young men to war—the sons of miners, the son of the barber, and the son of the postmistress. Many young men from the camps entered the service—some who left school before graduation, some who left wives and children. Because of the decline in the work force, women replaced the miners in various positions, ranging from "boney pickers" at the tipple to electrician and mechanic apprentices. The camps uniformly supported the war effort, buying war bonds, conserving materials, and conducting scrap drives.

When the need for coal decreased in the mid-1950s, the viability of the coal camps ended as well. Towns were dismantled, houses were sold and moved, and residents sought out other places to live and work. Almost as subtly as they became real communities, the camps were quickly gone—much like the industry that created them. In 1957, with the closing of the last coal mine, a lifestyle never to be duplicated had vanished.

At the high point of the mining operations, each of these camps was home to hundreds of people. These mining communities helped to keep the nation warm, kept the trains running, and contributed significantly to the war effort. Their place in history and the services they provided should not be forgotten.

One

Reliance

A Camp that Earned Its Name

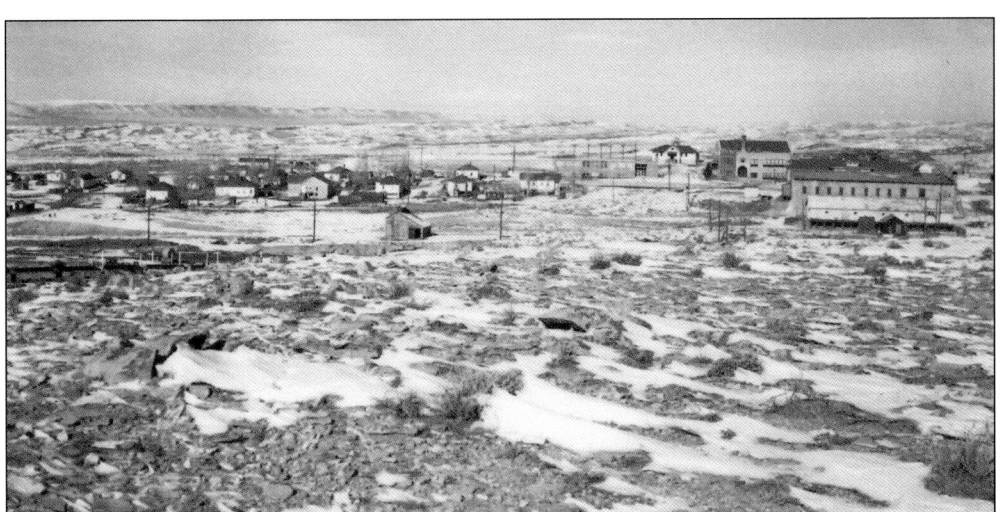

Reliance. Reliance, located seven miles north of Rock Springs, was home to hundreds of coal-mining people from 1910 to the late 1950s. It was known for a strong community spirit, good working conditions, high-quality coal, and a modern steel tipple. Reliance High School centralized School District No. 7 and united the coal camps. The mines closed in 1953, the high school in 1959, and the elementary school in 2003. This picture was taken in the mid-1950s. (Courtesy of CCR.)

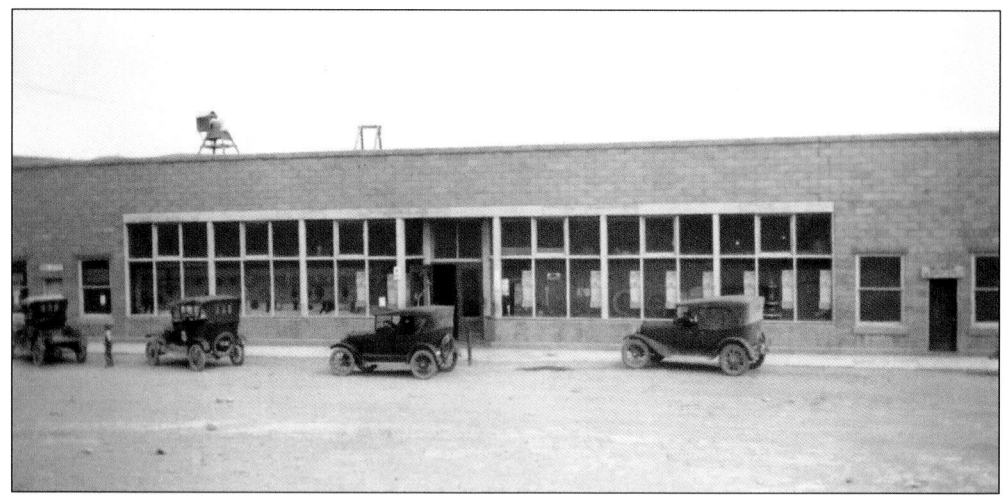

HEART OF RELIANCE. In the early 1920s, the Reliance UPCC complex was a center of business activity and provided many services for camp residents. In this image, the mine office is at left, the UPCC store is in the center, and the post office, which opened in 1910, is at right. This building was located in the middle of the camp, between Sand Camp and Middle Camp. (Courtesy of CCR.)

I OWE MY SOUL TO THE COMPANY STORE. The typical UPCC store carried a variety of merchandise, including miners' pails, furniture, tires, clothing, and food. Residents could charge their purchases, so many families did not get much of a paycheck. Store managers worked to meet the needs of residents who could not get to Rock Springs to shop. Beginning in 1930, Walt Johnson was the manager and Rudoph Ebeling was the union butcher. (Courtesy of SCHM.)

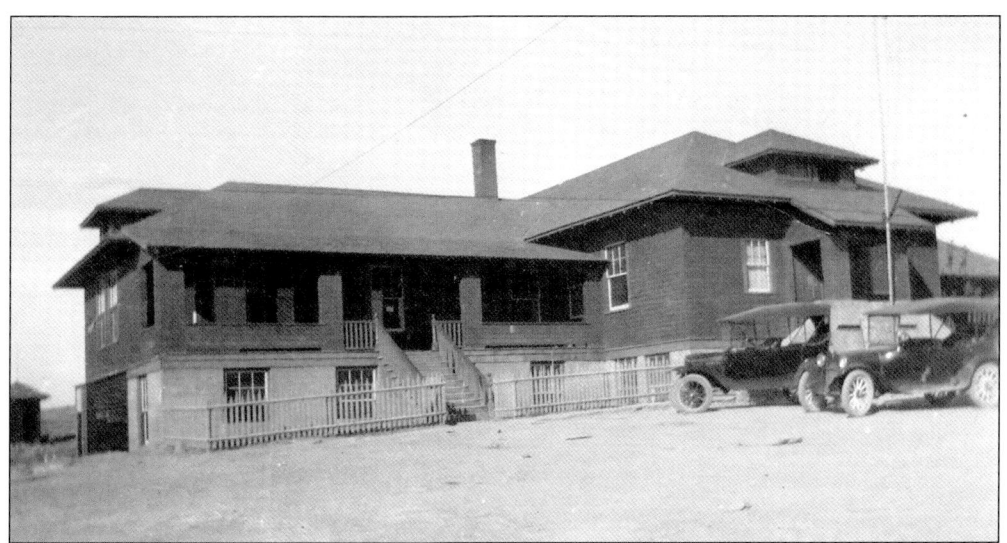

SOUL OF RELIANCE. The Bungalow, pictured in the 1920s, was the center for camp social activities and consisted of an activity room and a kitchen. In the middle was a large amusement hall where picture shows, roller-skating parties, dances, and large community affairs were held. The right side was the doctor's office. The basement housed the Pool Hall and a barbershop, where residents could enjoy light libations, ice cream, and candy while sharing stories, playing pool, or getting a haircut. (Courtesy of CCR.)

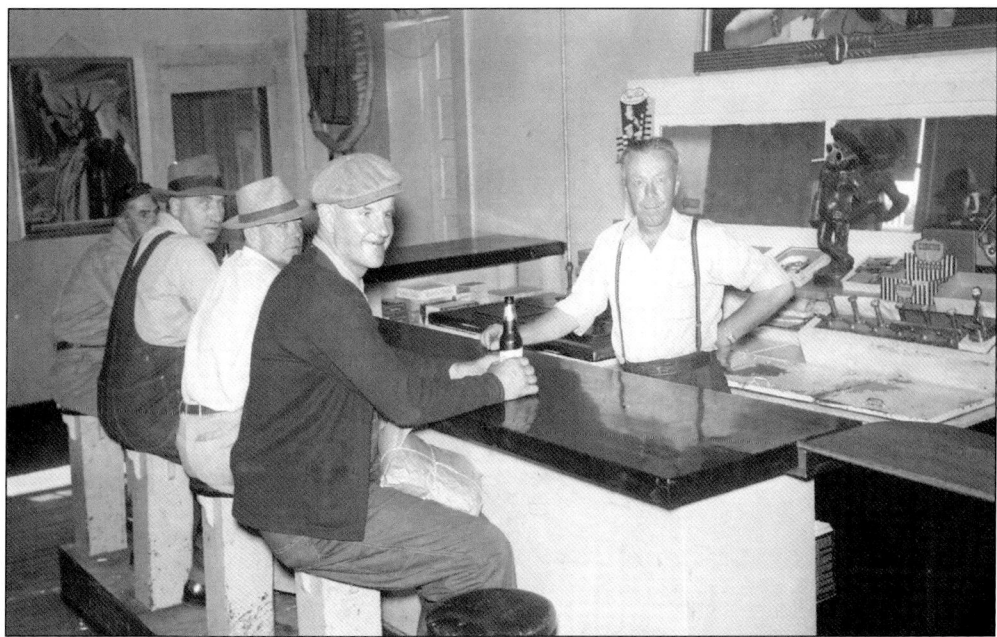

CAMP COUNSELOR. The Pool Hall, owned by Otto Canestrini, was a gathering place for both young and old. A disciplinarian, Canestrini shared many words of wisdom with those who came for a soda, ice cream, a game of pool, or—for the miners—a beer. Hanging on the walls were pictures of the Statue of Liberty and camp boys in the service. Otto sold the Pool Hall to Sam Canestrini in 1948. (Courtesy of Gloria Tomich.)

11

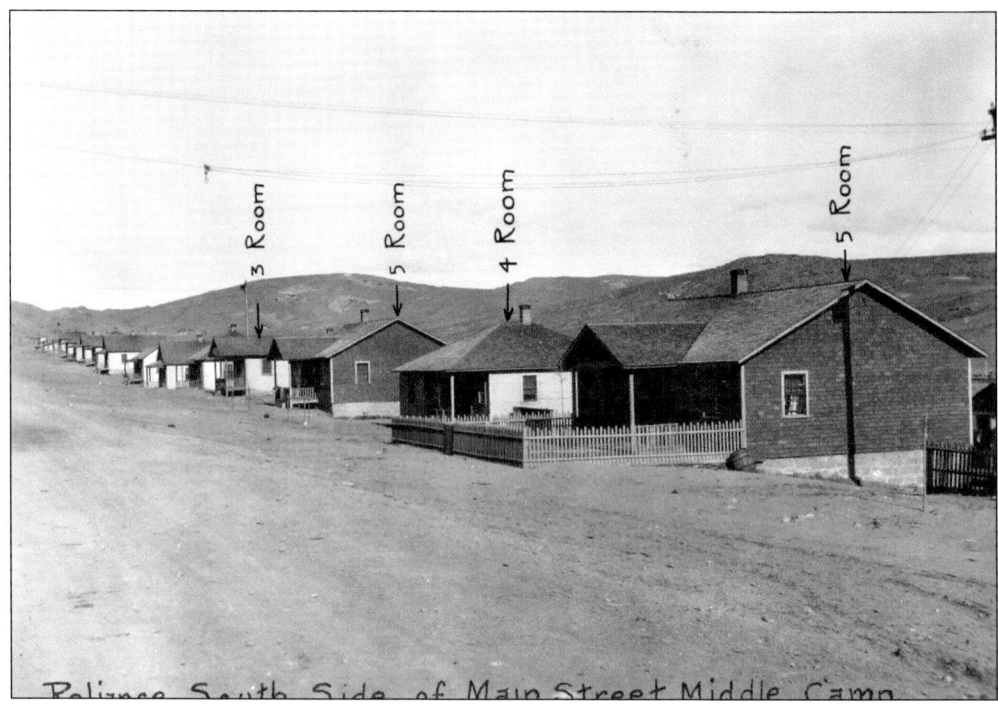

EARLY RELIANCE HOMES. Early homes in Reliance looked mostly alike, except for size. They were located in one of four sections of Reliance: No. 1 Camp, Upper Camp, Middle Camp, or Lower (Sand) Camp. Rents ranged from $11 for a three-room house to $20 for a five-room home with running water. (Courtesy of CCR.)

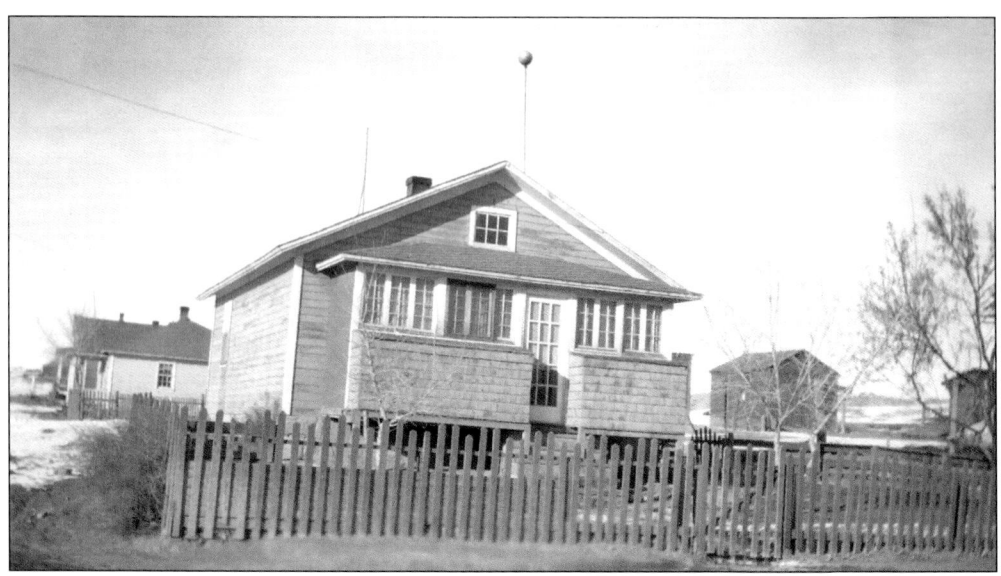

SAND CAMP HOME. Lower Camp was commonly referred to as "Sand Camp." The Canestrini family lived in this Sand Camp house, with its modern front and completed yard, during the 1940s. As the camp was more established, homeowners planted yards and trees and installed fences. Phone lines were also installed. A paved street and concrete sidewalk in Middle Camp were welcome upgrades. (Courtesy of Gloria Tomich.)

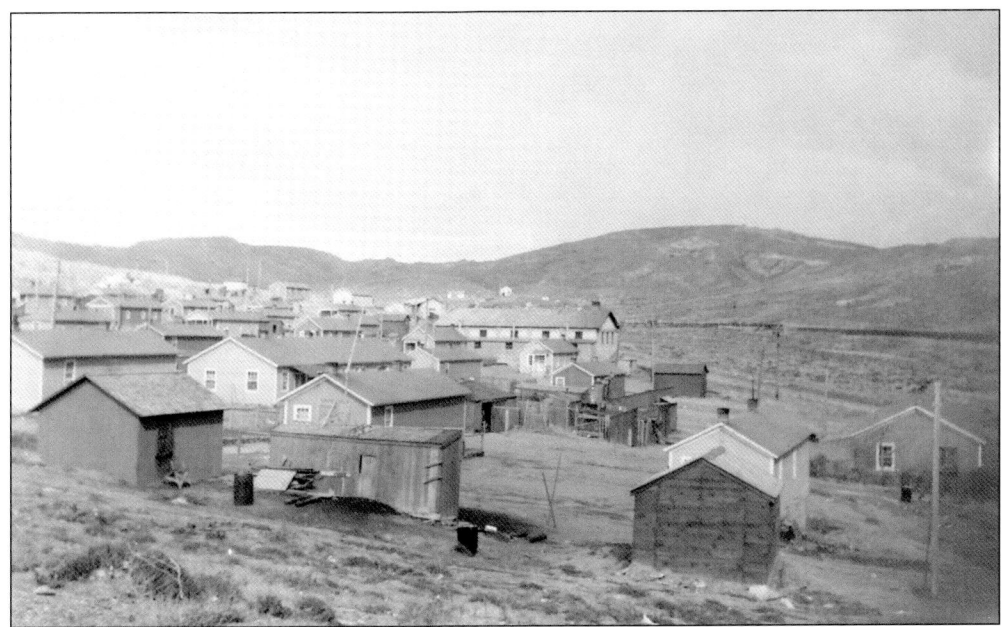

No. 1 AND UPPER CAMP. No. 1 and Upper Camp, located at the top east end of Reliance, contained an assorted variety of buildings, including unique homes, a boardinghouse, the bathhouse, and mining buildings, as well as the mine. The road and loaded coal cars can be seen in the background at far right as they leave the mine. (Courtesy of SCHM.)

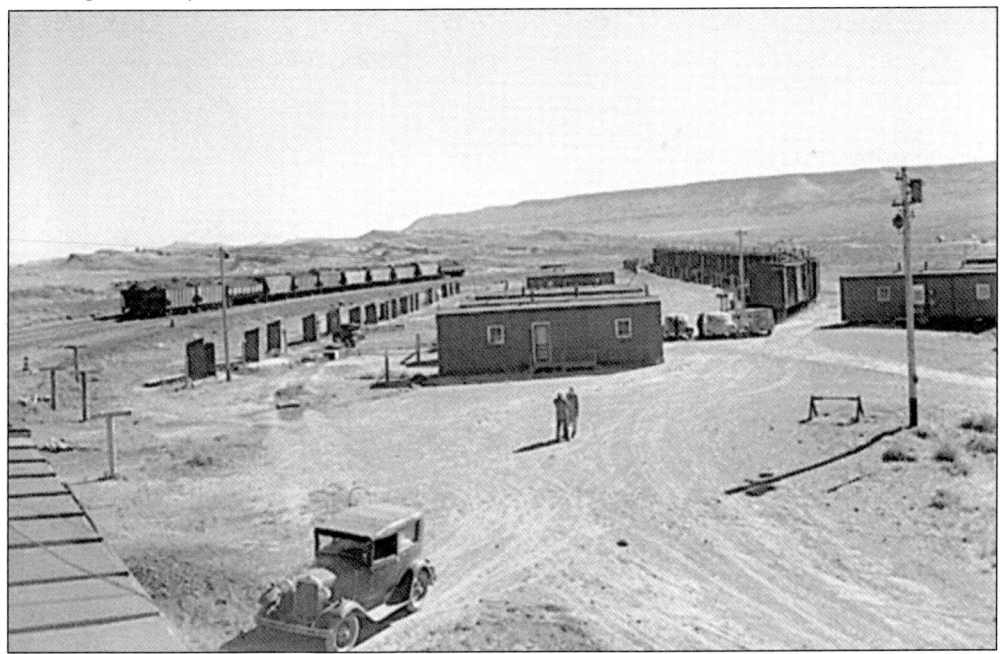

TEMPORARY HOUSING. With World War II requiring increased coal production, the UPCC had to provide housing for new miners and their families. As an emergency measure, the UPCC obtained 30 condemned boxcars from the Union Pacific railroad. They were removed from the wheels and fashioned into temporary living quarters at the bottom of the camp. The long line of outhouses was often referred to as the "Gateway to Reliance." (Courtesy of CCR.)

13

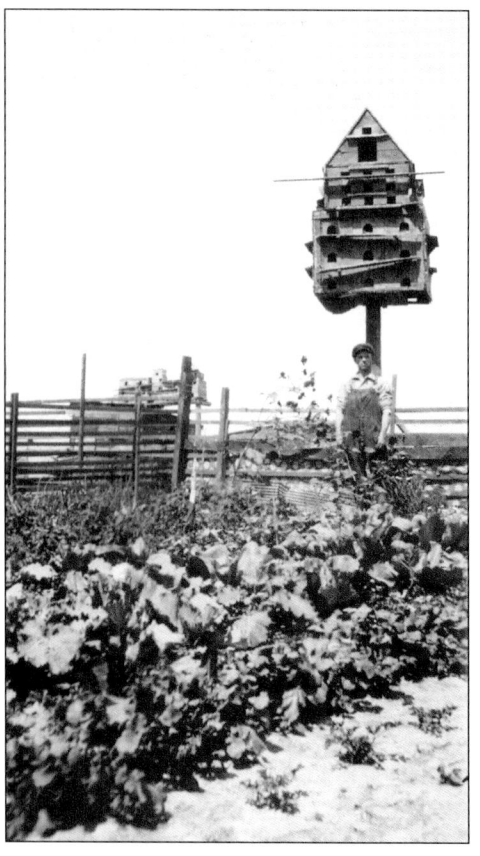

I Think that I Shall Never See a Poem as Lovely as a Tree. To encourage residents to improve their properties, the UPCC initiated Garden Contests, with monetary awards given as prizes. Here, Marjorie Vollack admires one of the trees in her family's yard. A UPCC machinist, Edward Vollack (Marjorie's father) turned a rocky ledge into a beautiful yard, winning several contests in the 1930s. (Courtesy of SCHM.)

Amazing Aviary. In 1924, Frank Menzago adorned his prize-winning garden with an elaborate birdhouse. Both friend and fowl could see this well-crafted garden decoration from quite a distance. A large family of birds made this multilevel abode their home for the summer. (Courtesy of SCHM.)

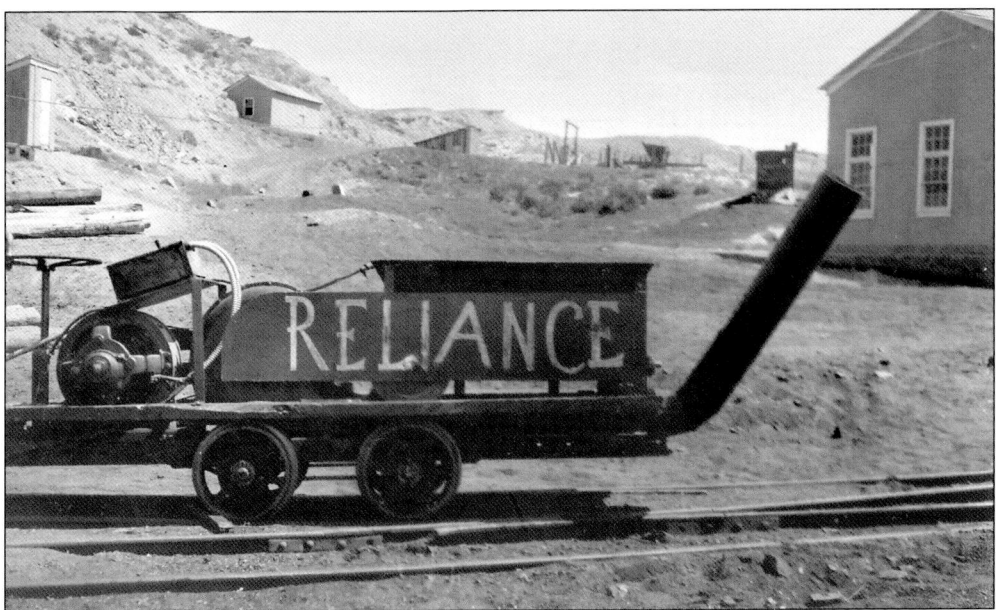

ROCK DUSTING. Mine No. 1, located at the top of Reliance, opened in 1910. The UPCC reported that safe mining practices were being employed at the mine. In 1911, this machine was experimentally used to apply adobe dust to haulage ways and man-ways to prevent the propagation of coal dust explosions. The effect of the dust on employees caused the experiment to be abandoned until 1924, when shale was used instead of adobe. (Courtesy of SCHM.)

BATHHOUSE AND LAMP HOUSE. Men leaving the mine made two stops before going home. The first stop was at the lamp house, where they left their mine lamps for recharging and repair. They then entered the bathhouse, on the other side, to leave their "pit" clothes and shower. In this 1932 image, lamp man Alex Spence is shown in front of the lamp house; he worked for the UPCC for 33 years. (Courtesy of George Spence.)

RELIANCE NO. 7 MINE, 1951. This crew—from left to right, Fred Bradley (unit foreman), Dean Pyper (inserting tamping bag), Cecil Wathern (tamping), John Allen (preparing shot wires), and Fred Larson (carrying powder and caps)—prepares to shoot the coal. Extreme caution was used when preparing and handling explosives in order to avoid accidents. (Courtesy of SCHM.)

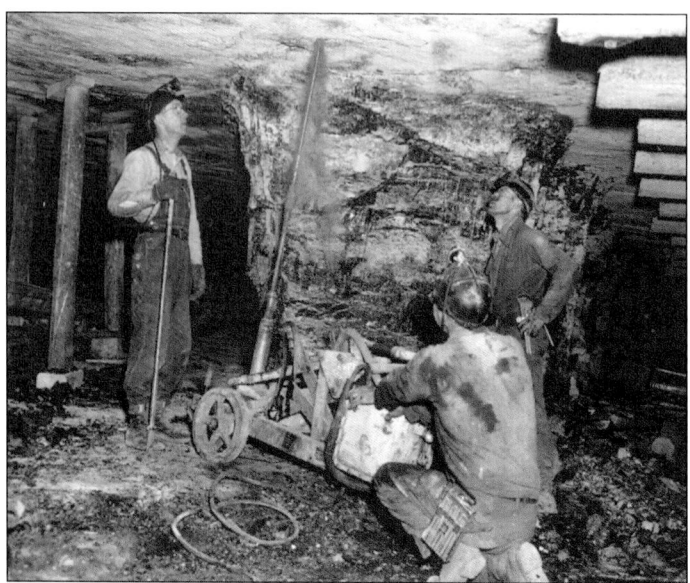

ROOF PINNING, 1950. Superintendent Lawrence "Jarbo" Welsh (left) supervises miners as they utilize a new method of roof suspension called pinning. This process involved reinforcing roof rock with anchored steel rods. This important technique was a means of reducing the high rate of accidents caused by falling roofs. (Courtesy of the Lawrence Welsh family.)

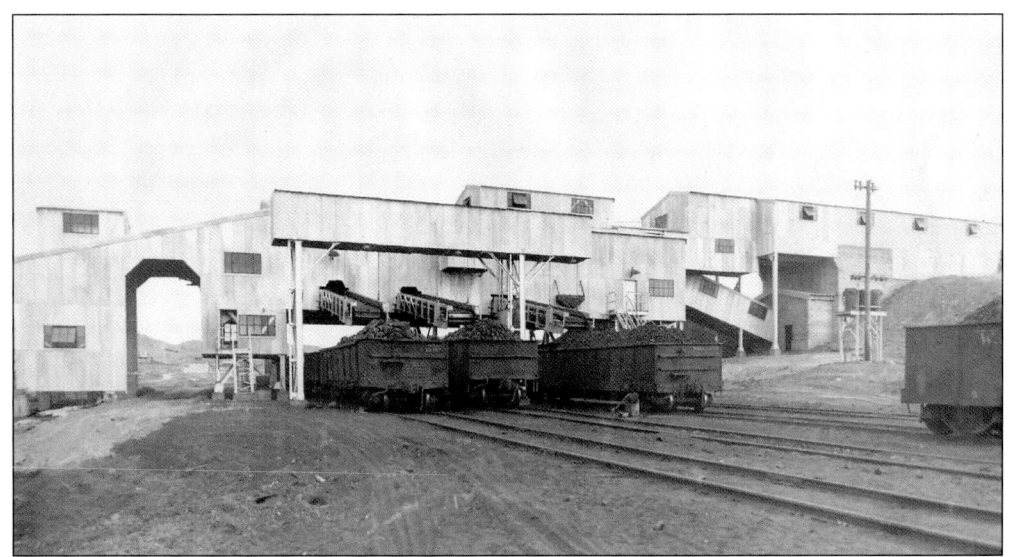

NEW TIPPLE. As the need for coal escalated during the 1930s, the UPCC determined a new tipple was needed to accommodate increased production in the Reliance mines. The Reliance tipple, built in 1936, was a modern steel tipple—the first one in Southwestern Wyoming. The contract awarded to the engineering firm of Allen and Garcia Company of Chicago cost $232,000. Burkhard and Sons of Denver did the steel work. (Courtesy of SCHM.)

BONEY PICKERS. During World War II, women could not work underground, but they could work on the tipples. These employees, referred to as "boney (slate) pickers," are, from left to right, Annie Krek, Christine Cukale, Zabia Mangelos, and Sumiko Hattori. Their job was to separate the slate and debris from the good coal. (Courtesy of Dudley Gardner and Western Wyoming College.)

17

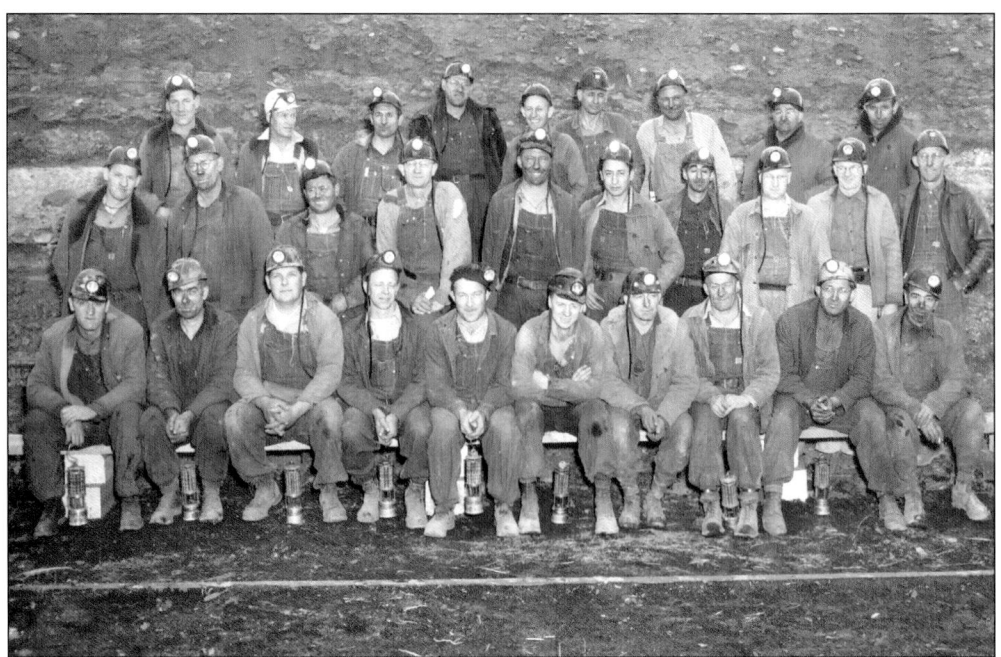

QUITE A FEAT. Miners from Reliance No. 7 won the national Sentinels of Safety Trophy competition for 1948 through 1950, working without a lost-time accident. They were honored at the Old Timers' Building; in attendance were Gov. Frank A. Barrett, Tom Burke of the National Safety Council, Assistant Secretary of the Interior Robert Rose, and I.N. Bayless (president of the UPCC). Superintendent Lawrence "Jarbo" Welsh (pictured below) accepted the trophy and individual certificates on behalf of his miners. Milton Friel, the No. 7 duckbill operator, gave the acceptance speech on behalf of the men. Welsh concluded the ceremony by saying, "Let's do it again." (Both, courtesy of CCR.)

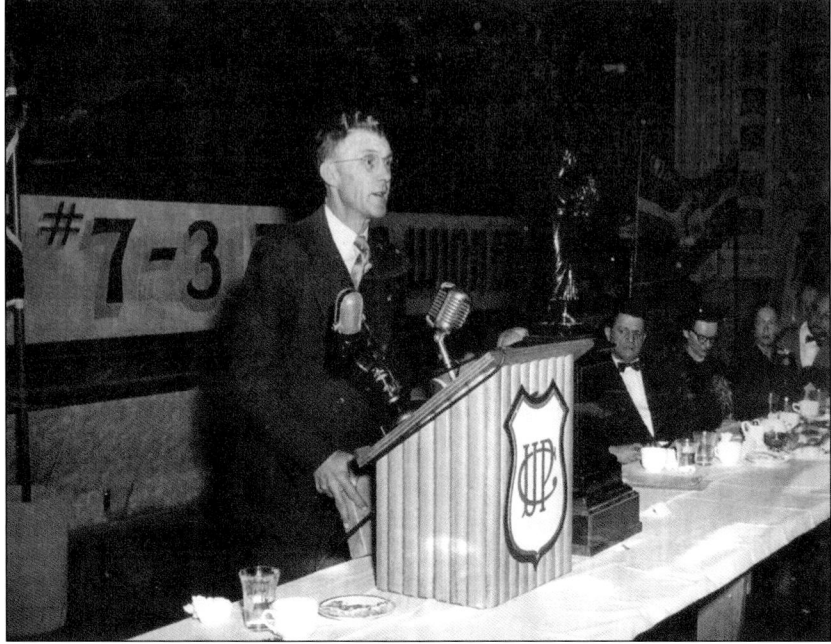

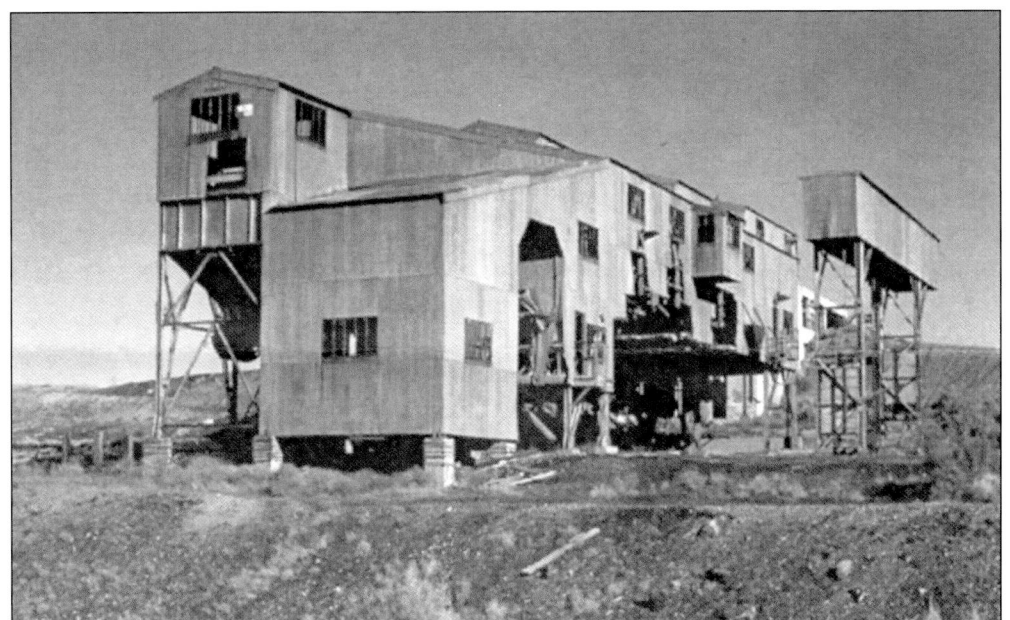

HISTORIC LANDMARK. In 1989, Gov. Mike Sullivan dedicated the tipple as a historic site, placing its care with the Sweetwater County Historical Museum. The tipple was one of two such structures left in the state, and the UPCC and Abandoned Mine Land Tax revenue funded renovations. Governor Sullivan told the Reliance schoolchildren attending the dedication ceremony that "the tipple reminds future generations of the past." It had outlasted the industry that created it. (Courtesy of SCHM.)

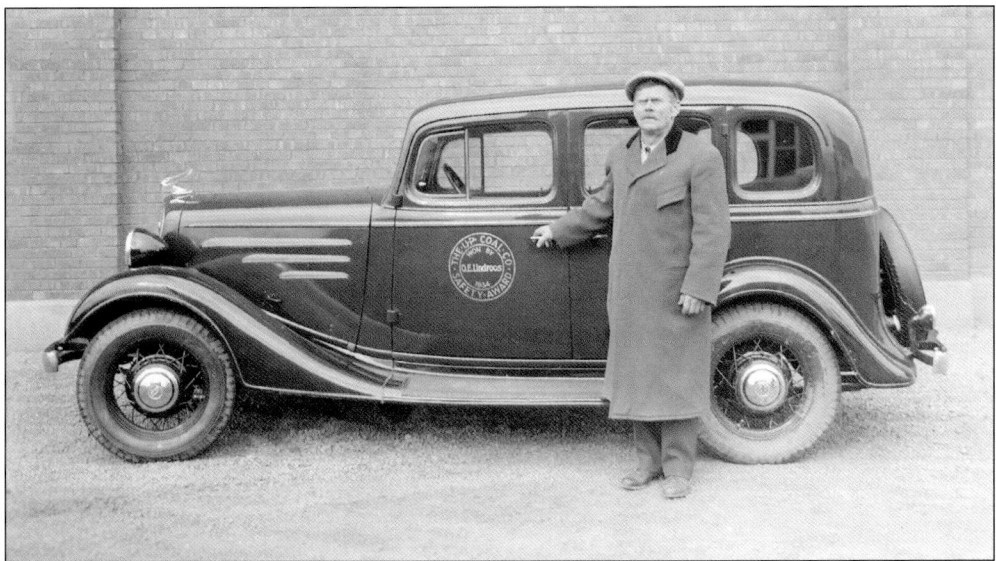

SAFETY WINNER. As motivation for adhering to safe working practices, the UPCC gave awards to eligible employees. Oscar E. Lindroos, employee of the Reliance No. 1 mine, won the automobile given as a first-place prize at the 1934 Annual Safety Meeting in Rock Springs. Lindroos was an old-timer, having been with the UPCC since 1902. In 1949, he—along with 12,000 other miners—retired under the United Mine Workers of America (UMWA) pension plan. (Courtesy of SCHM.)

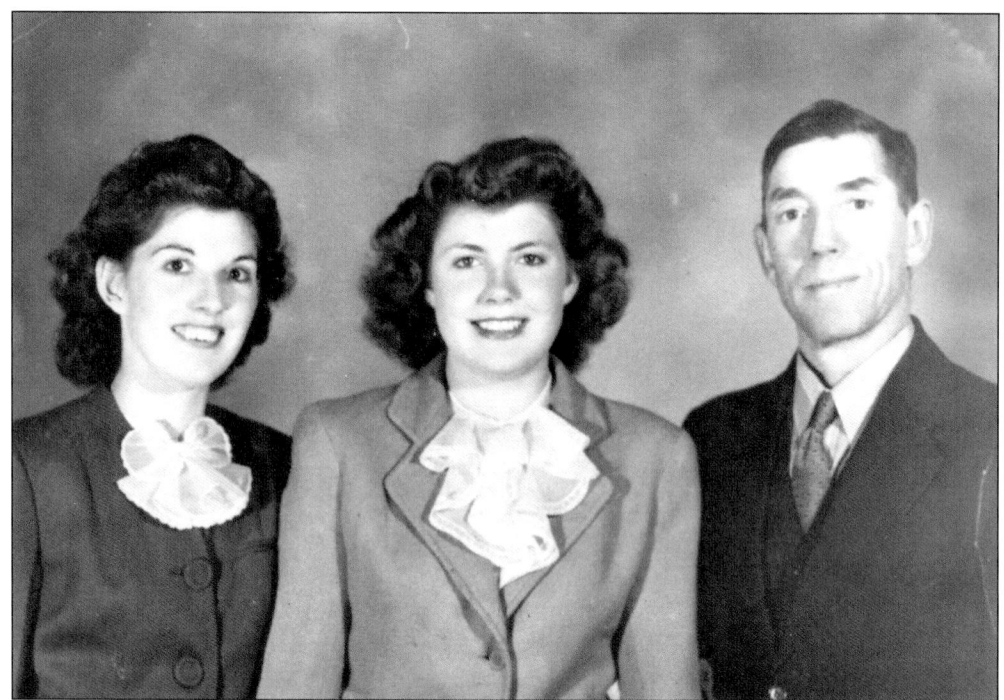

UNIQUE EXPERIENCE. Bernice Hamblin Boone (left) and June Hamblin Floyd (center) were initiated into the UMWA by their father, Clark W. Hamblin (right), president of the Reliance local union. Floyd made dummies for use in mine blasting, and Boone worked on the tipple during the war. They earned $2.83 per hour. The women's grandfather, Dougald McWilliams, was superintendent of the Reliance mines in 1918, and his home in Sand Camp became the teacherage for single female teachers. (Courtesy of CCR.)

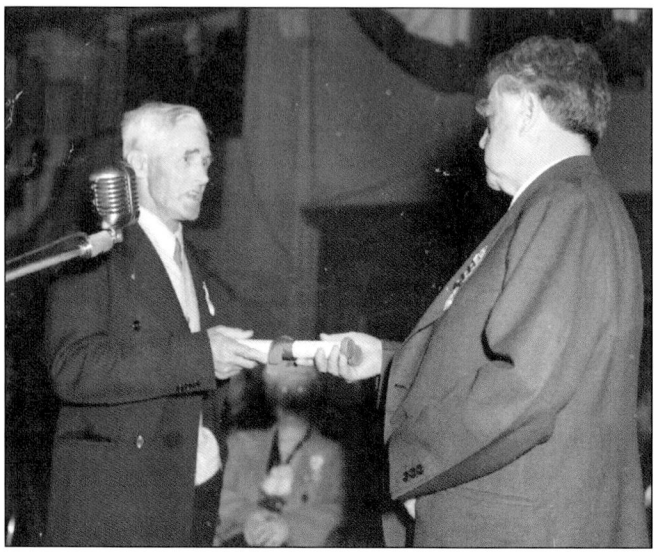

CHECK NO. 1—A HISTORIC OCCASION. On September 9, 1948, after working for 53 years in the coal mines of England, Canada, and Wyoming, Horace Ainscough, 62, was the first miner in the country to receive a $100 pension check from the UMWA. Ainscough (left) received the award from UMWA president John L. Lewis in Washington, DC. Ainscough began working in mines as a trapper boy in Wigan, Lancashire, England. (Courtesy of Diane Ainscough.)

FINNISH IMMIGRANTS. Mr. and Mrs. Matt Mattonen immigrated to the United States from Finland and moved to Reliance in 1911. The family included, from left to right, Flora (the first baby born in Reliance), Hazel, Margaret (Pussila), Bill, Matt, Ray (a member of the first RHS graduating class in 1931), and Edna. Matt Mattonen worked in various UPCC mines for 38 years. In 1933, he lost his life in a rock fall in the Reliance mine. (Courtesy of the Menghini family.)

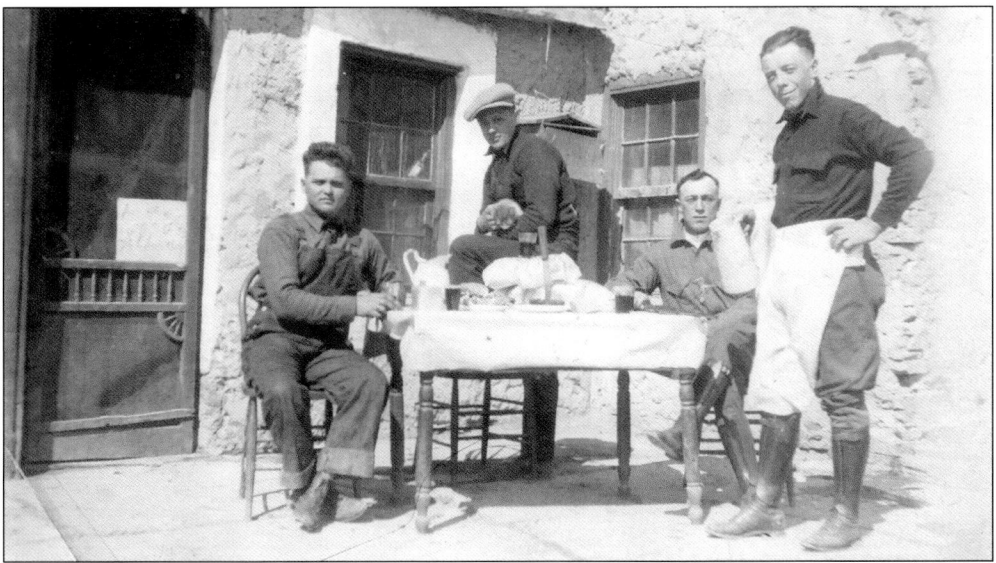

THE "BATCH." Four Italian miner friends—from left to right, Constante Caresia, Sam Canestrini, Guido "Bombi" Franck, and Otto Canestrini—enjoy lunch outside a limestone rock home above No. 1 Camp in upper Reliance. Attilio (Otto) and Sisinio (Sam) Canestrini emigrated together from Cloz, Trento, Italy; they had the same last name but were not related. In 1925, they married sisters in a double wedding, and both owned the camp Pool Hall at different times. (Courtesy of Gloria Tomich.)

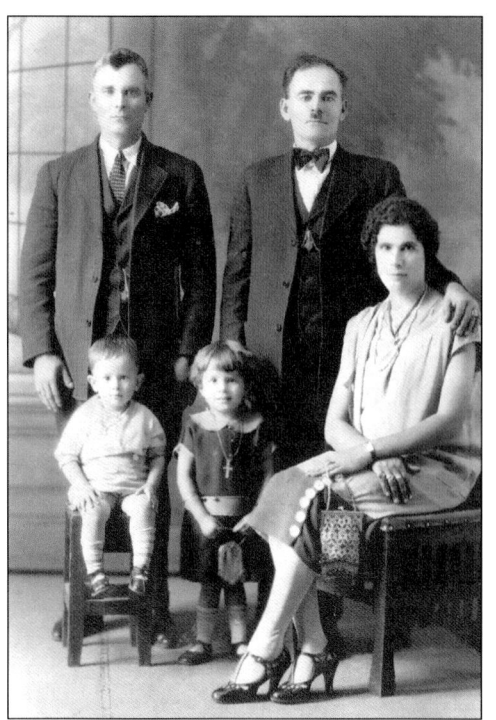

GREEK IMMIGRANTS. Shown in this photograph are brothers Joe (left) and Tony Varras; Tony's wife, Mary; and Tony and Mary's children, George and Florence. To gain citizenship, Tony joined the US Army in 1917, fighting in France. He returned to Crete, married Mary Vasilandonakis, and they immigrated to Reliance in 1924, arriving by train from Ellis Island. Mary was pregnant with their son Spiro at time of this picture. Daughter Florence died from a brain tumor at age 10. (Courtesy of Spiro Varras.)

BRITISH IMMIGRANTS. In 1933, the Ainscough family consisted of, from left to right, (first row) Horace, Rich, and Gwen; (second row) Jack and Eileen. Both parents had emigrated from England. The Ainscoughs were very involved members of the Reliance community. Mrs. Ainscough was a kind neighbor, helping anyone in need as well as working for the British War Relief effort. She was one of the outstanding women of the coal camps. (Courtesy of Diane Ainscough.)

EMBLEM OF HONOR FAMILY. During World War II, the departure of so many young men was difficult on families. Mike Korogi and his wife, Elizabeth, had five sons in the armed services at one time—Charles, Kenneth, Andrew, Leslie "Les," and Harold "Bud." The Korogi family was awarded the Emblem of Honor for service to the war effort. Pictured from left to right are (first row) Kenneth, Elizabeth, Mike, Mary Lou, and Andrew; (second row) Jack, Bud, Christina, Charles, and Les. (Courtesy of the Andrew Spence family.)

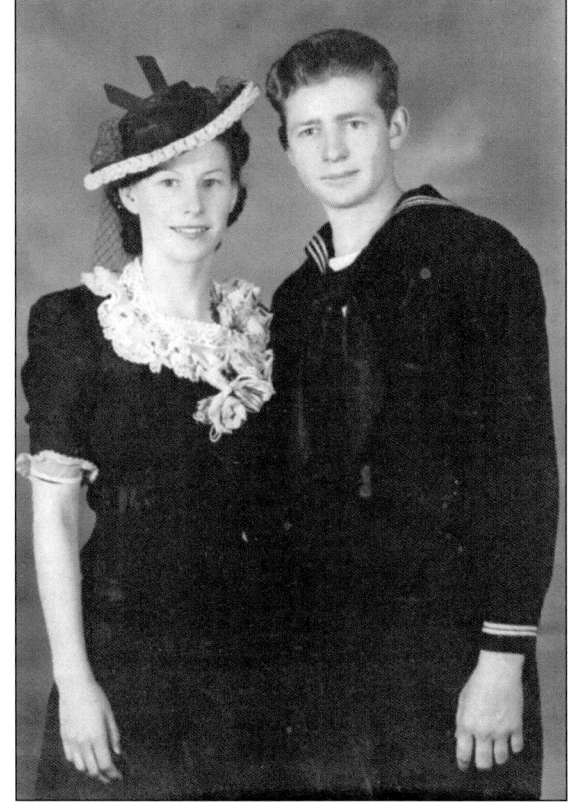

WARTIME WEDDING. Aware that young men in the service might not return to their homes and sweethearts, many couples decided to get married. In 1943, a wedding took place between Frances Toly, daughter of Sam and Mary Toly, and US Navy seaman second class Paul Reuter, the son of Julius and Louise Reuter. Immediately after the wedding, a reception was held at the home of the bride's parents in Reliance. (Courtesy of Paul Reuter.)

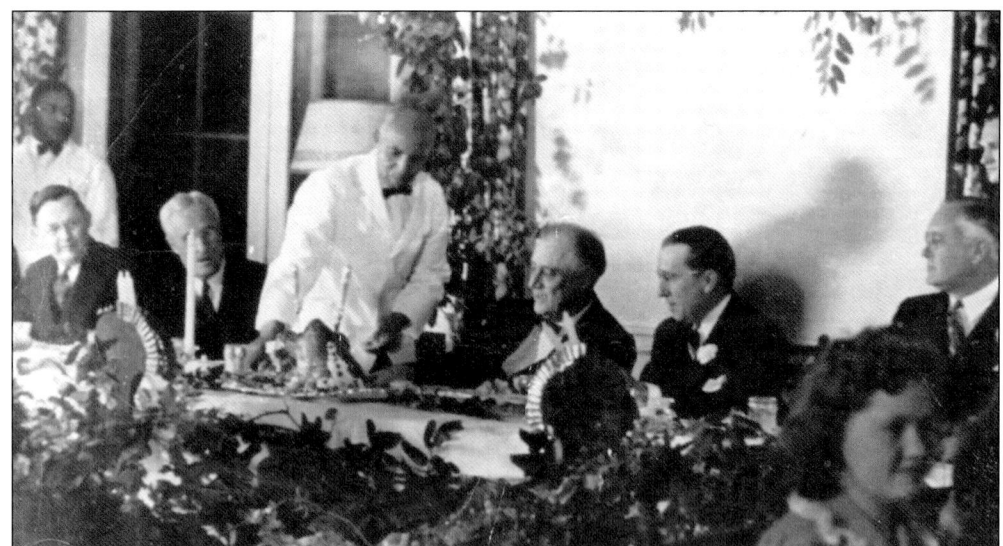

POLIO VICTIM MEETS WARTIME PRESIDENT, 1941. A victim of polio (also known as infantile paralysis) since she was two, 18-year-old Afton Baxter (right foreground) was the first Wyoming resident to be treated at Warm Springs, Georgia, through help from Roosevelt's National Foundation for Infantile Paralysis. On Thanksgiving Day, she dined with Pres. Franklin D. Roosevelt, saying that she was "so nervous her wheelchair shook," but she praised Roosevelt's ability to put everyone at ease. (Courtesy of Diane Ainscough.)

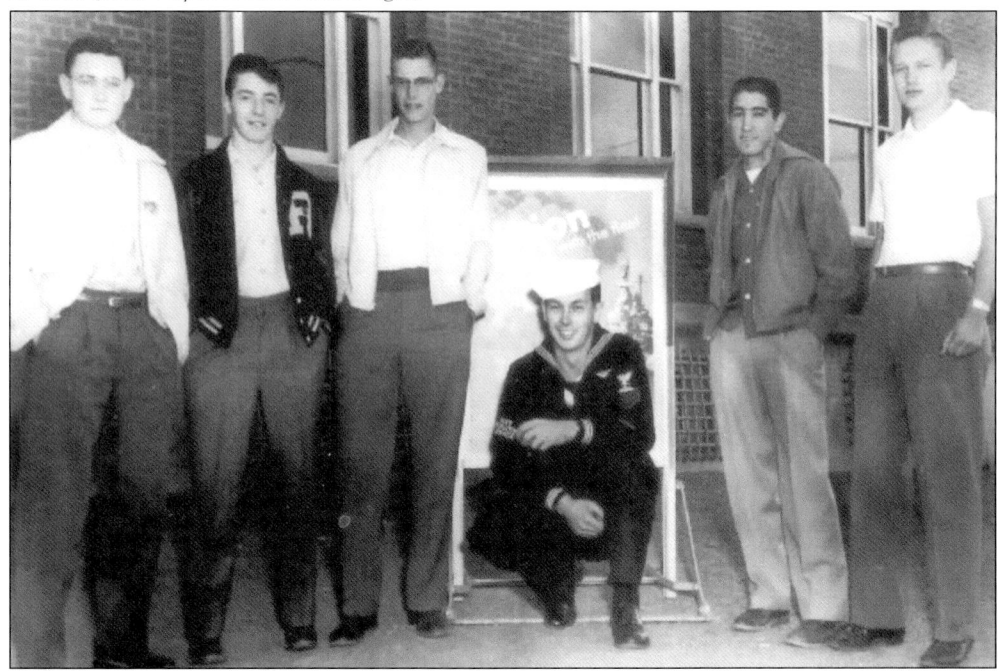

READY TO SERVE THEIR COUNTRY. In 1952, five young men from the camps were recruited and left for boot camp together, ready to face another world conflict. From left to right, Keith Sines, Richard Lee, James Spence, Tony Garcia, and Les Zelenka were sworn in at Salt Lake City before reporting to San Diego for 11 weeks of recruit training. A Navy recruiter kneels at center. (Courtesy of George Spence.)

SAFETY FIRST. Safety and first aid were promoted among the UPCC employees as well as their families. Reliance had a First Aid Hall in the 1920s where first-aid techniques were demonstrated and practiced. Hugh Kelly, an expert in mine safety, served as the first-aid instructor for Girl Scouts, women of the camp, and the mine rescue teams, shown in the above picture. (Courtesy of CCR.)

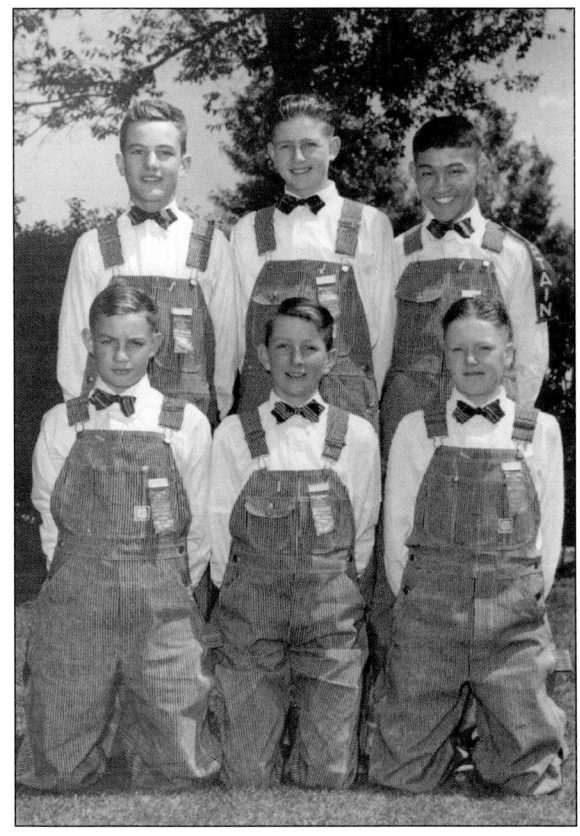

SECOND-PLACE FINISHERS, 1939. Scouts were involved in camp first-aid programs and the UPCC's annual First Aid Contests. The members of this Boy Scout team are, from left to right, (first row) James "Junior" Zelenka, Gordon Hughes, and Thomas Stewart; (second row) John Peppinger, Paul Reuter, and Yutaka Hattori. They were a well-dressed team, with matching bib overalls, white shirts, and bow ties, and each won a gabardine jacket for their second-place finish. (Courtesy of CCR.)

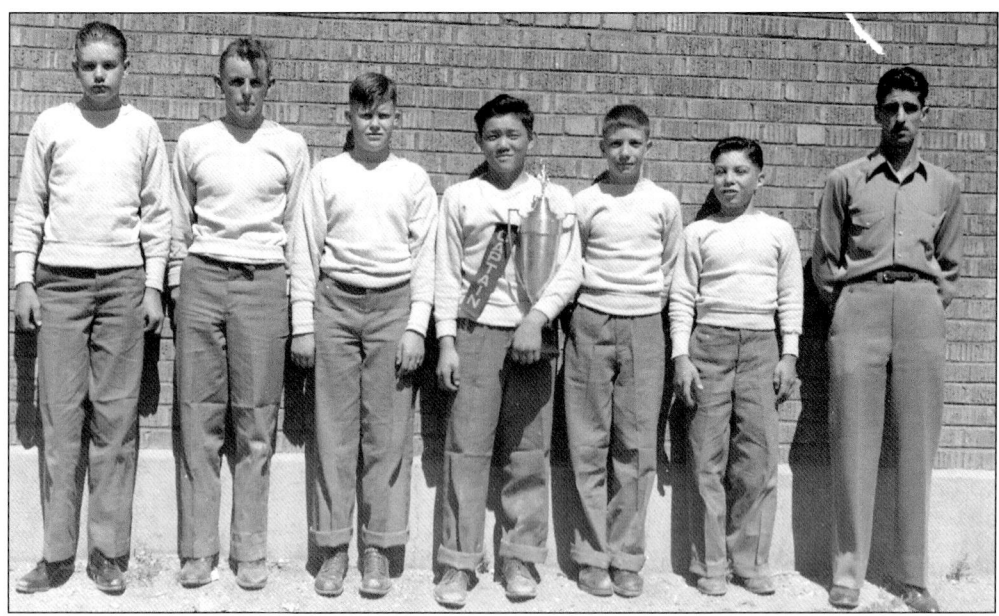

BIG WINNERS, 1944. The first-place finishers of the First Aid Contest pictured here are, from left to right, Ralph Zelenka, Richard Ainscough, John Kovach, Sam Hattori (captain), Stanley Kouris (patient), Michael Fresques, and team instructor Mack Fresques. Each team member won $25 for his efforts. Mack Fresques was instrumental in the safety and first-aid programs of the camp. (Courtesy of SCHM.)

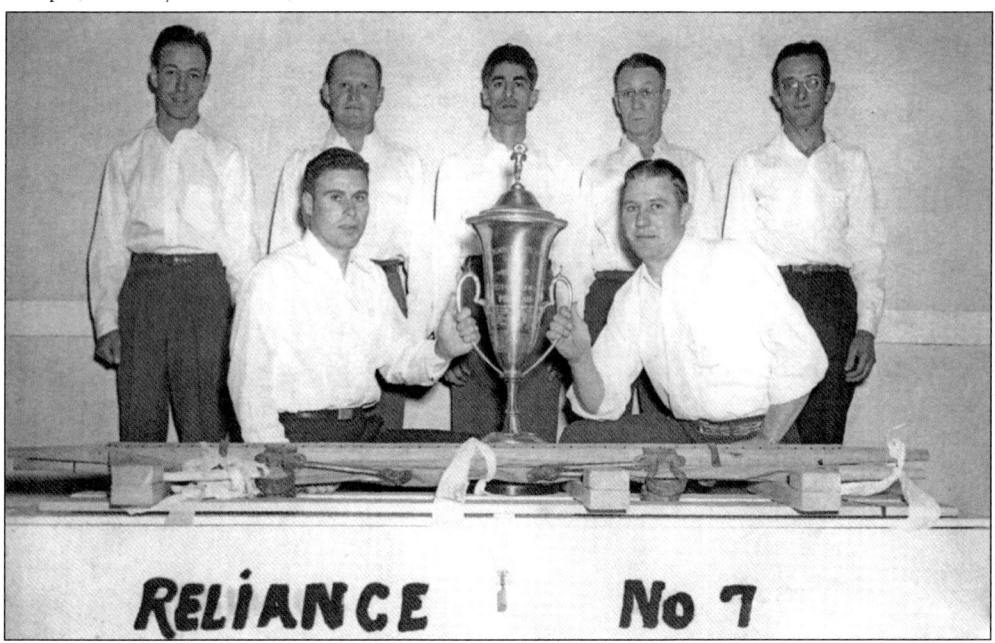

BOUND FOR OHIO. The Reliance No. 7 mine team was victorious in the 1951 First Aid Contest, held as part of the Old Timers' celebration. They represented the UPCC in Columbus, Ohio, at the National First Aid and Mine Rescue Contest. Pictured here from left to right are (first row) Leon Becquart and John Sepich; (second row) Pete Milonas, Ken Stephens (captain), Mac Fresques, Ralph Selby, and George Korfanta. (Courtesy of Dudley Gardner and Western Wyoming College.)

Bride and Bridesmaid. Camp activities started at an early age. In 1912, cousins Hilta (left) and Ellen Spence (ages four and two and a half, respectively) dressed in wedding finery for a Tom Thumb playlet. Hilta was the daughter of Charlie and Carrie Spence, and Ellen was the daughter of "Scotty" and Cassie Spence. These playlets became popular following the infamous wedding of "little people" Charles Stratton and Lavinia Warren. (Courtesy of Mary Ann Kershisnik.)

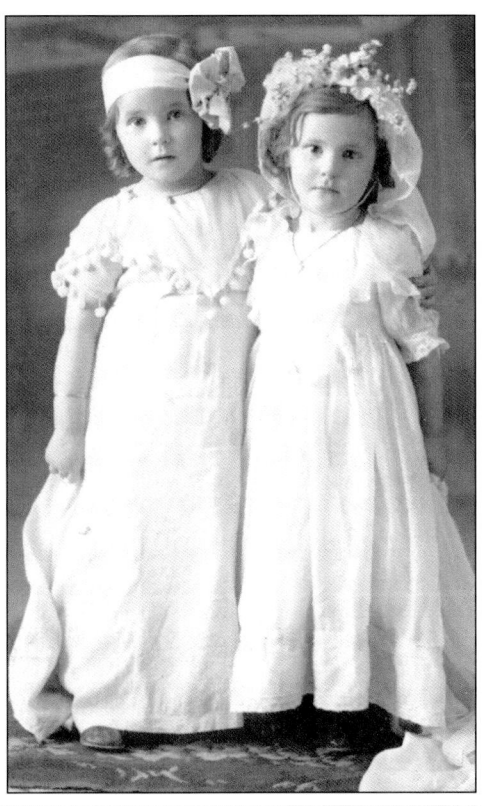

Sunday School, 1920s. Religious education was important to camp parents. Primary provided for the LDS young people, the priests of the Rock Springs churches came to the camps for catechism classes, and a Greek priest would visit the camps on special occasions, such as Easter. For those of other religions or denominations, the Union Sunday School fulfilled the camp's religious needs, meeting in school buildings and the Bungalow.

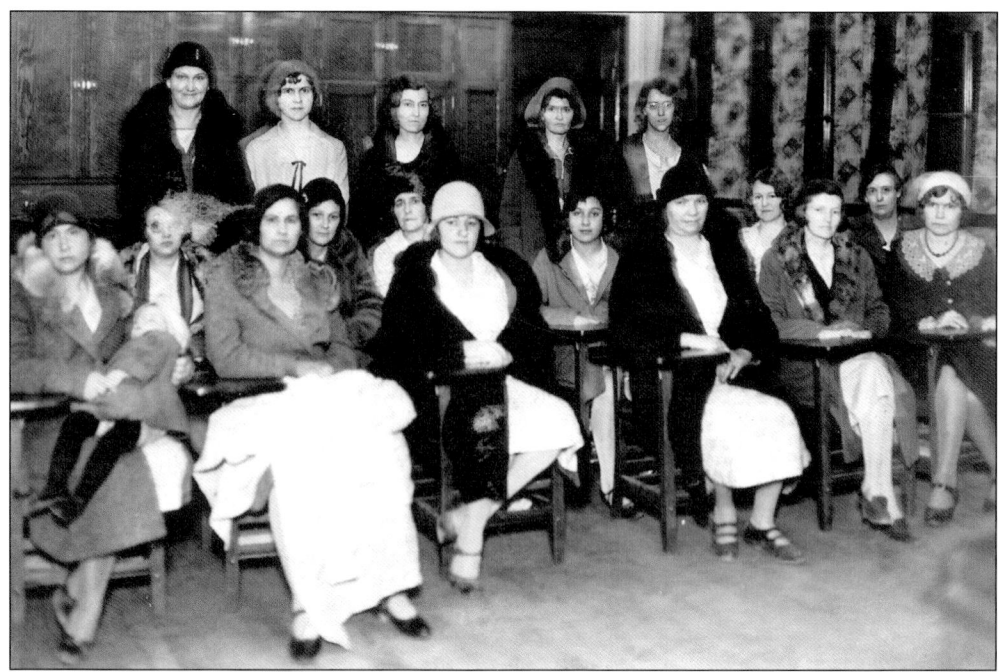

HOME DECORATION CLASS. The UPCC endeavored to provide classes for housewives so that they could improve their homes. In 1931, Miss Kearns, (second row, far right), the RHS home economics teacher, taught a class of 18 ladies the finer points of decorating and arranging. (Courtesy of SCHM.)

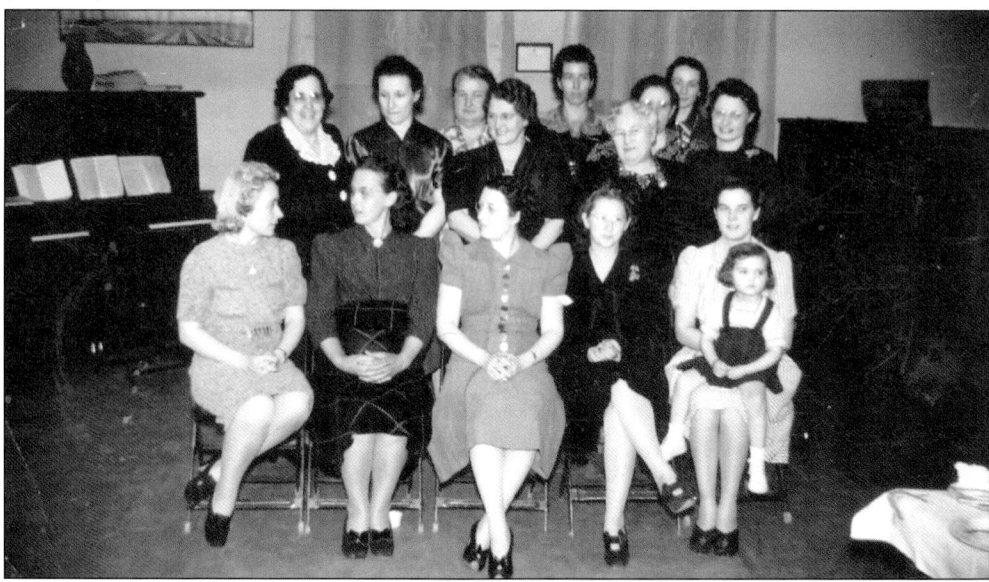

RELIEF SOCIETY, 1942. The LDS Relief Society, organized around 1914, was one of the oldest women's organizations in Reliance. The society's goal was educational and cultural development, as well as undertaking acts of neighborly kindness and helpfulness. Meeting at the Bungalow, they enjoyed a "lesson," refreshments, and a pleasant get-together. Many members belonged to other religions but enjoyed the companionship of their LDS friends and neighbors. (Courtesy of CCR.)

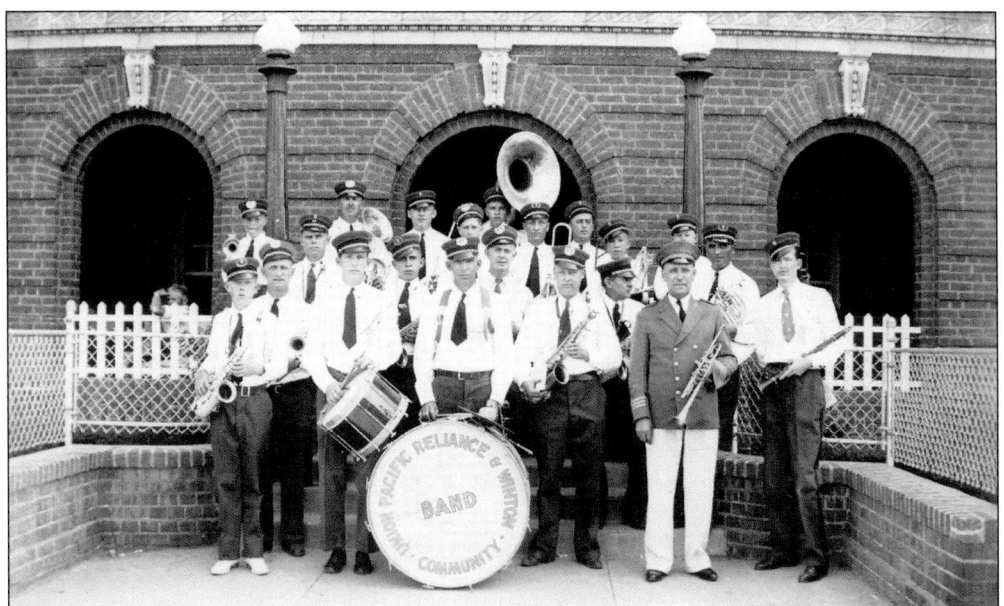

UPCC BAND. Talented musicians from Winton and Reliance joined to form the UPCC Community Band. Here, they pose in front of the Elks' Lodge, ready to perform favorite selections before the Old Timers' parade in the 1930s. Their leader was Jim Sartoris (in jacket and white pants), who was hired by the UPCC to start the band. (Courtesy of SCHM.)

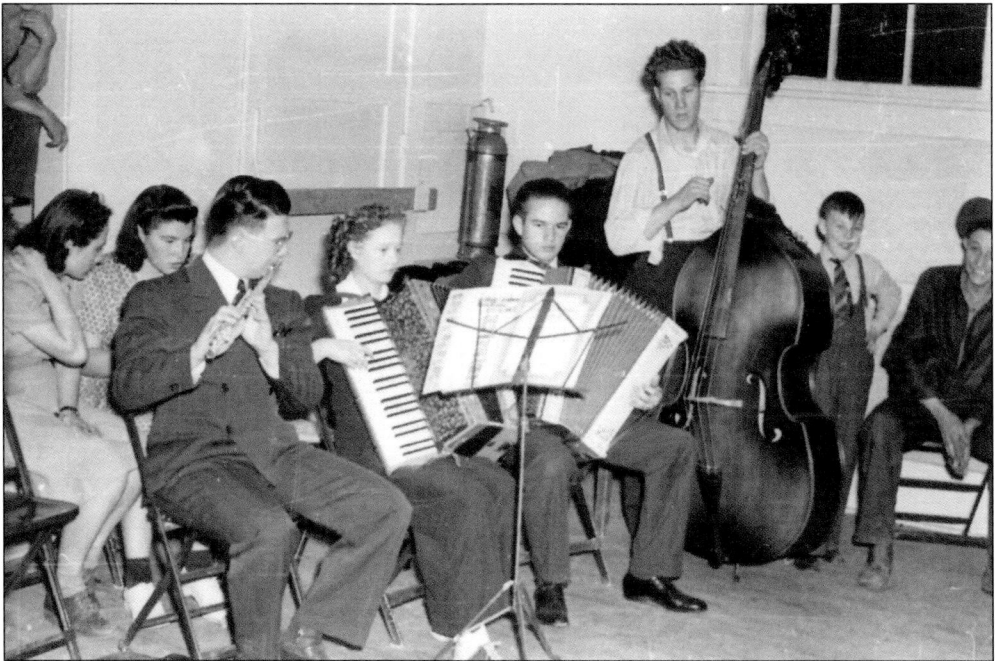

YOUNG MUSICIANS, LATE 1930S. The Reliance Community Council sponsored a children's dance once a month. The entertainment was provided by a community youth orchestra, including Thomas Hall (flute), Margy and Roy Zelenka (accordion), and Fred Kallas (bass). Dancing was a popular activity in the communities, and these dances gave the children an opportunity to socialize and learn to dance. (Courtesy of SCHM.)

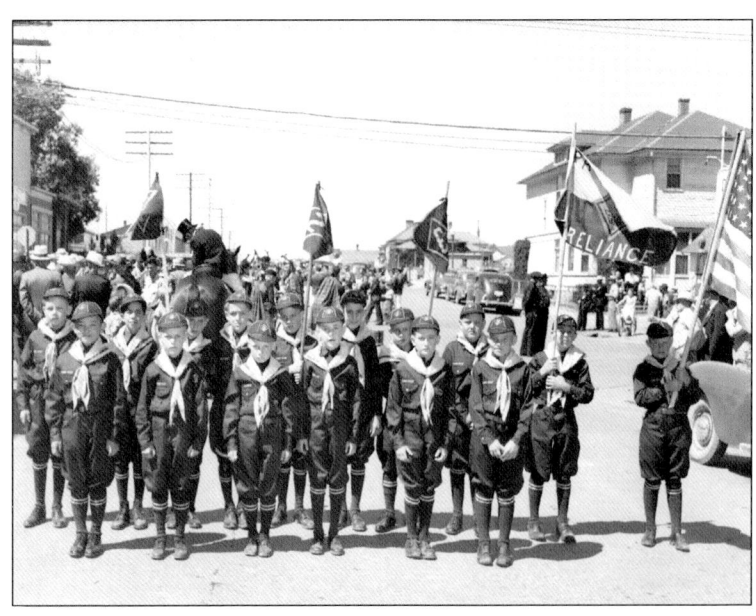

CUBS LEAD THE WAY. In the late 1940s, the Cub Scout troop of Reliance participated in the Old Timers' Day Parade. They carried flags and banners as they led UPCC dignitaries, Old Timers, and first-aid teams to the Old Timers' Building. (Courtesy of SCHM.)

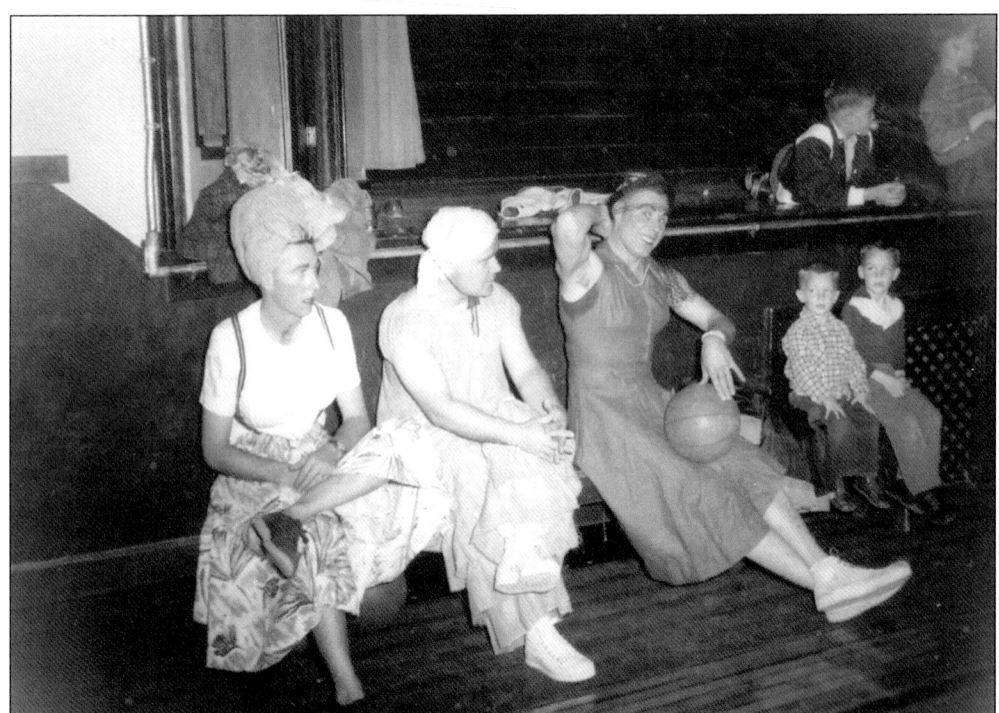

COMMUNITY SPIRIT. In the middle of the 1957 basketball season, a group of coal camp men demonstrated their basketball acumen. A benefit game was held at Reliance between the Puny Punks and the Terrorists to bring translator television to the camp. There were a lot of laughs, as the men were dressed like women. The NCAA never would have approved the uniforms! (Courtesy of CCR.)

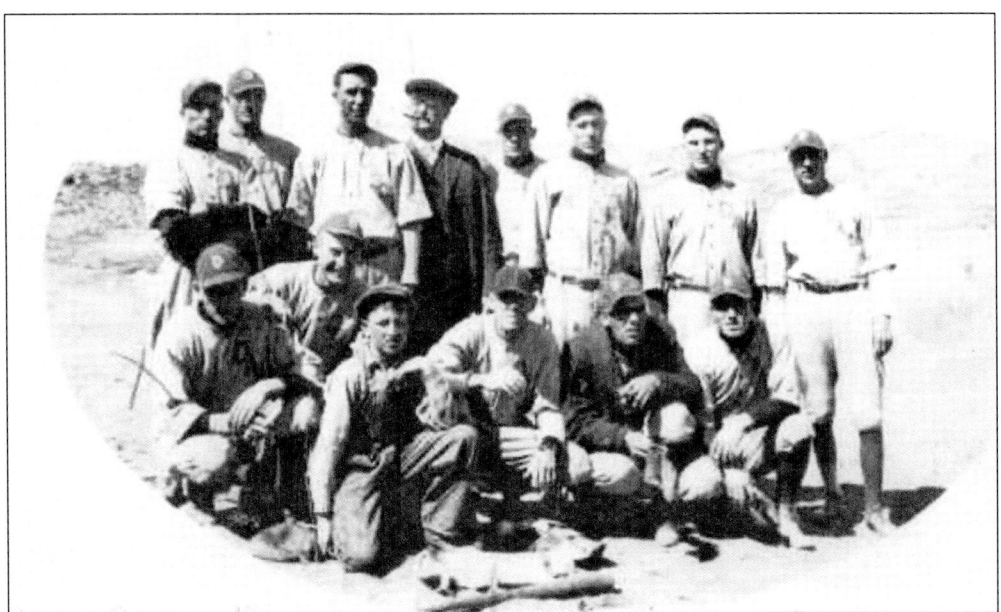

PENNANT WINNERS, 1926. In the 1920s, the UPCC hired a professional to organize a Reliance baseball team. Team members included "Old Man" Buckles (the camp plumber), Tom Hall, Clarence Holmes, Charles Holmes, Jack Rafferty, Jim Spence, "Squirt" Sellers, "Ding" Spence, Zeigler (the pro), Bill Sellers, and Floyd Roberts. Reliance beat Superior 3-2 for the UPCC pennant. Over 1,000 people witnessed the best game ever played in this region. (Courtesy of CCR.)

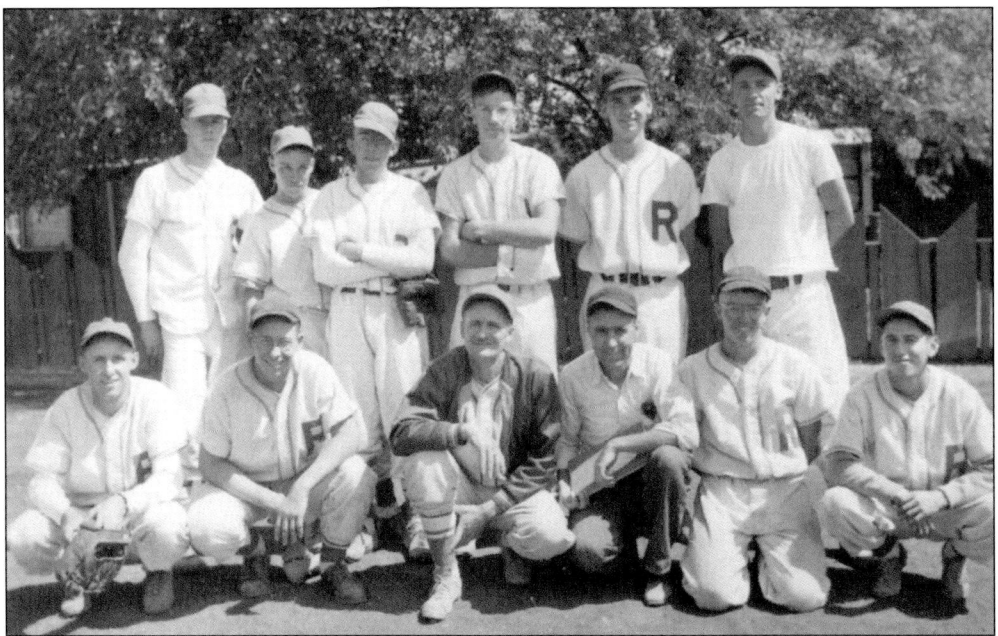

BOYS OF SUMMER. Youthful players participated in league baseball during the summers from 1948 to 1951. Pictured here are, from left to right, (first row) Jim Styvar, Dick Frederick, George Robinson (manager), Henry Telck (scorekeeper), Don Jelouchan, and Julian Vigil; (second row) "Bud" Nelson, Jeff Allen, Spiro Varras, Stan Kouris, Mickey Evans, and J.V. Vidakovich. Nelson went on to play baseball at the University of Wyoming. (Courtesy of Gary Allen.)

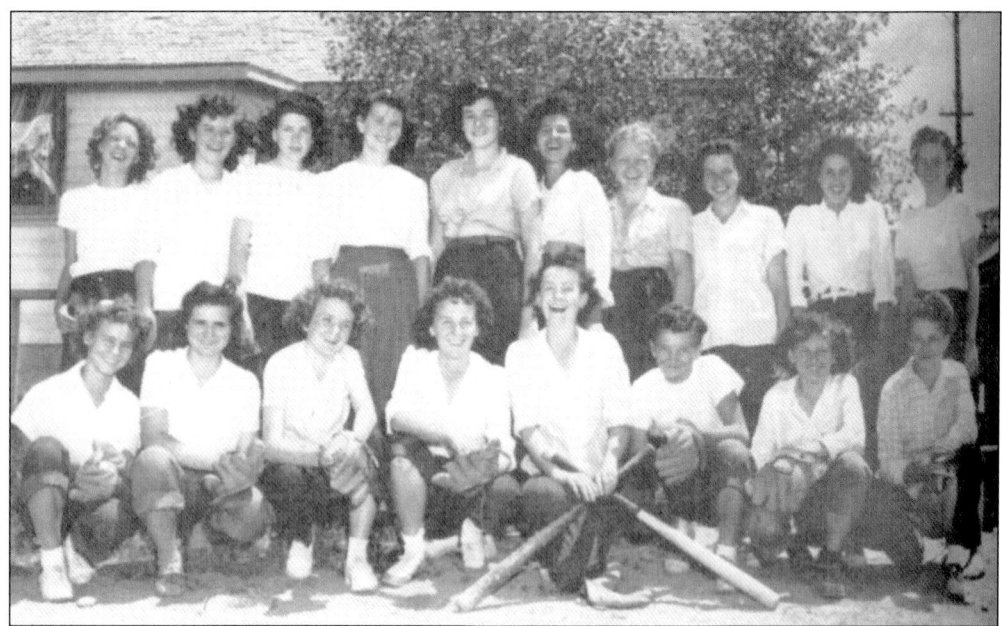

COAL CAMP CUTIES, 1946. Sports were not limited to the young men. The girls' softball team was formed as part of the summer recreation league. They called themselves the "Coal Camp Cuties." The Reliance team extended a challenge to Rock Springs girls for a series of softball games, and they swamped the Rock Springs girls three straight times. They had a great season! (Courtesy of CCR.)

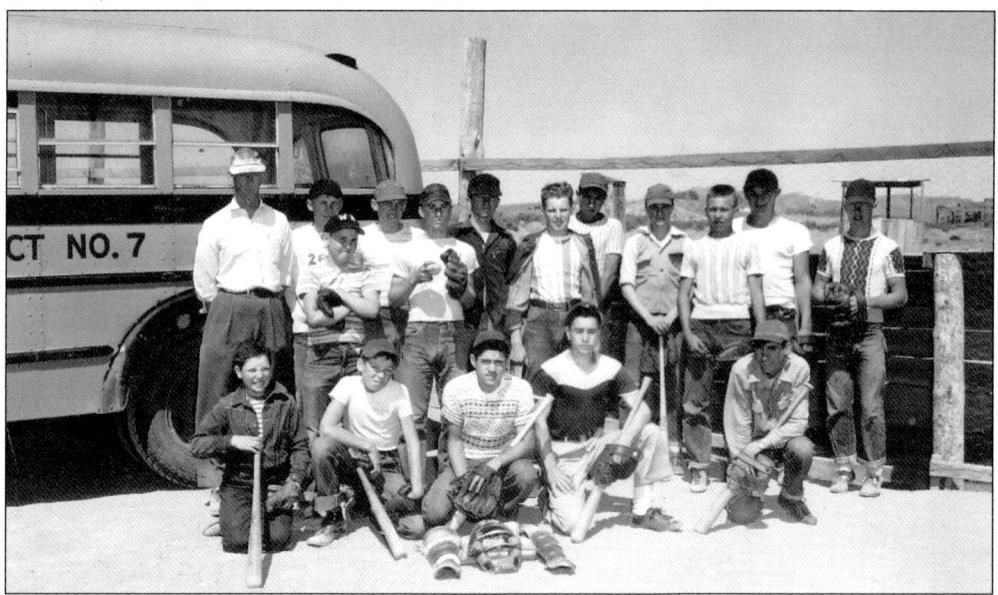

AMERICAN LEGION JUNIOR BASEBALL. As part of the summer recreation program, Jack Smith coached a baseball team of teenage boys. Pictured here in July 1950 are, from left to right, (first row) Ronald Wardlaw, John Vidakovich, Perfecto Chavez, Ernie Fresques, and Jim Stroud; (second row) Donald Delgado, Paul Guigli, Gene Wardlaw, and Bill Palcher; (third row) Coach Smith, J.R. While, Mike Sawick, Oscar Pirnar, Eloy Garcia, Jack Rafferty, John Maffoni, and Jim Mecca. (Courtesy of CCR.)

RELIANCE SCHOOLS. The first schools were in a three-room house and the union building. In 1914, students moved to the "white school house," which housed eight grades in three rooms and served as a community hall and church. When the new high school was built, these students moved to the basement, and the white school became a church. It later became a school again until the new elementary school was built in 1953. (Courtesy of CCR.)

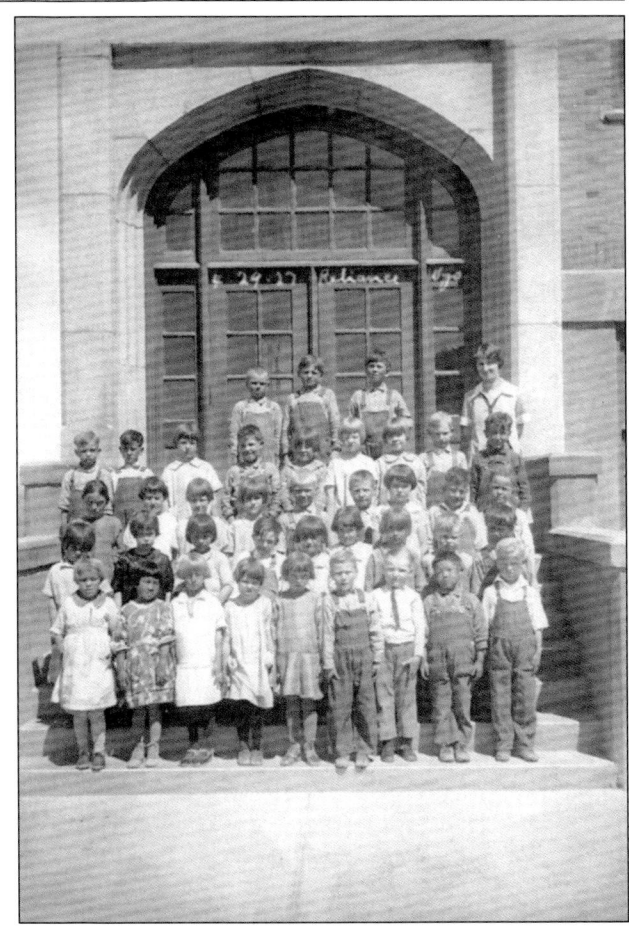

ELEMENTARY STUDENTS, 1927. Room was found in the basement of the new high school for the students who had been attending the "white school house" on the hill. Bib overalls for the boys and dresses with long stockings for the girls seemed to be acceptable school attire. (Courtesy of CCR.)

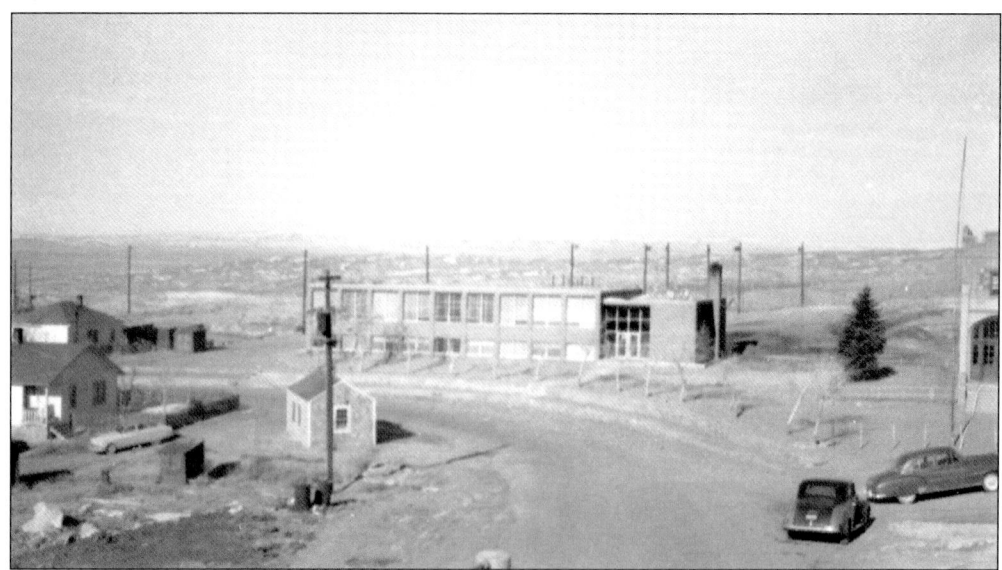

NEW ELEMENTARY SCHOOL. In 1953, elementary students moved into the new school located to the left of the high school. It was a modern facility containing six grades upstairs. The basement served as a lunchroom, a music room, and a place for community and school affairs. School District No. 7 consolidated with District No. 1 in 1959, but the elementary school remained open until 2003. It is now an apartment building. (Courtesy of CCR.)

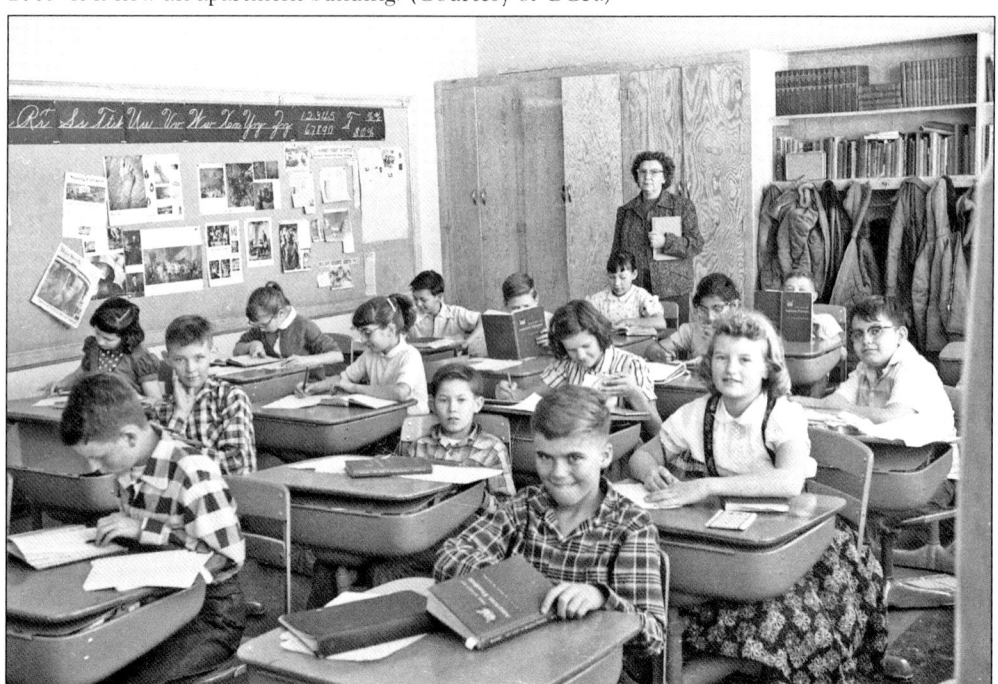

MODERN CLASSROOMS. In the new building, students enjoyed classrooms with large windows, good heat, modern bathrooms, and places for them to work, store their materials, and learn. Many of the students in this 1957 fourth-grade class went on to college and became productive in their adult lives, attributing their successes to the foundation they received in the Reliance schools. Vendia Spence (in the back) was the teacher and principal. (Courtesy of CCR.)

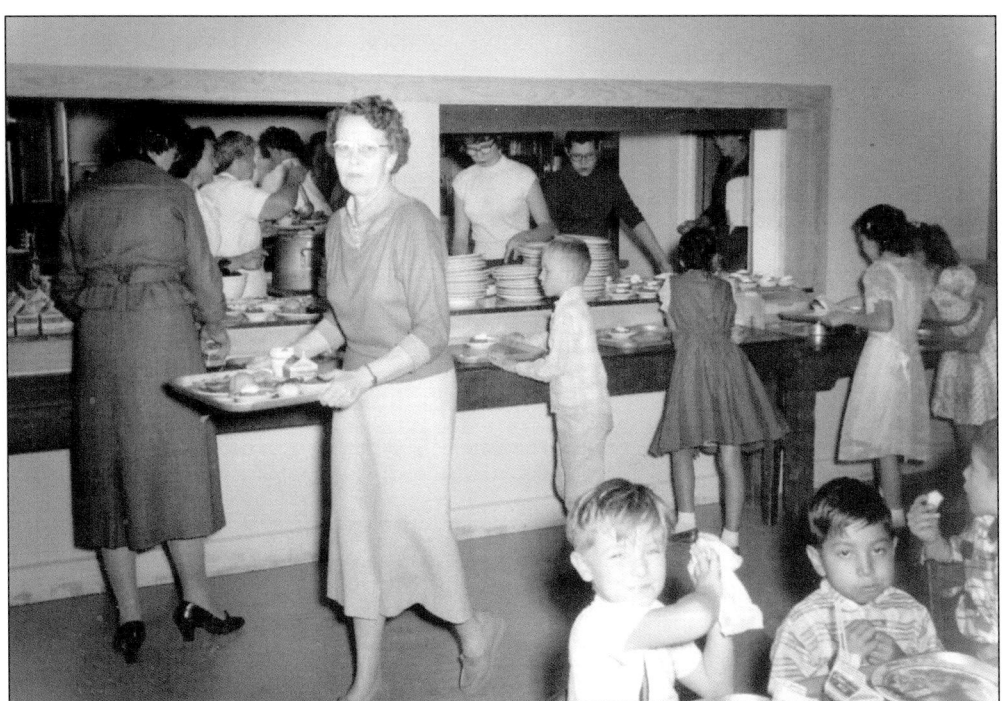

LUNCHROOM LINES, 1957. Elementary teacher Dovey Hanley filled her tray with lunchroom specialties and a half-pint of milk. The lunchroom served both elementary and high school students and was located in the basement of the new elementary school. Home economics teacher Edythe Belle Porenta was in charge of planning the meals, which were made from government surplus food. No soda pop or candy was allowed in the lunchroom. (Courtesy of CCR.)

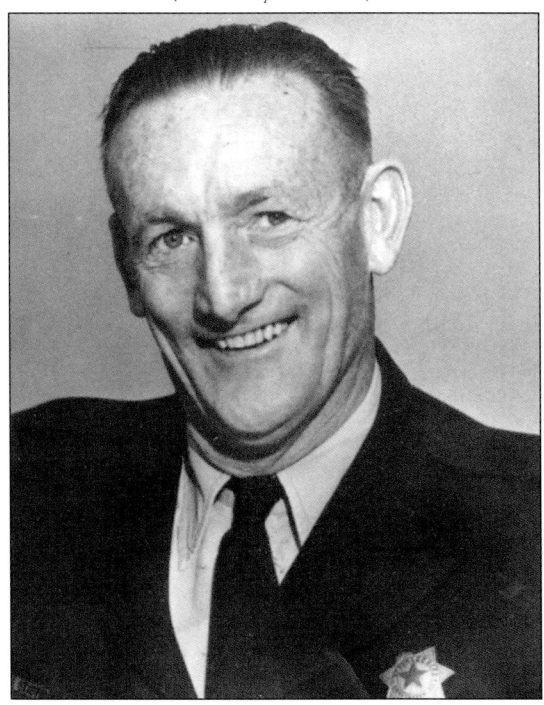

SUCCESS STORIES. The schools produced many successful camp kids. James Stark, a Scottish immigrant, became a US citizen at the age of 10. He served in the US Navy for nine years and was in Pearl Harbor when Japan attacked. A professional boxer in his early 20s, Stark later started a youth boxing program. He was a Rock Springs policeman, undersheriff, and later the 23rd sheriff of Sweetwater County, retiring in 1969. (Courtesy of SCHM.)

FROM SCIENCE CLASS TO MISSILES AND SUBMARINES. Launching a rocket and building a submarine in a 1958 science class directed Dale Groutage's career choice—he earned bachelor's, master's, and doctorate degrees in engineering and science from the University of Wyoming. As a member of a US Navy team, he helped design the HARM (High Speed Anti-Radiation) missile and worked on developing quiet submarines. In 2006, Groutage launched an unsuccessful campaign for the US Senate. (Courtesy of CCR.)

DISTINGUISHED ALUM. Ralph Archuleta received his early education in Reliance and attended the University of Wyoming, graduating magna cum laude in 1969 with a physics degree. A master's and doctorate in earth science led him to a professorship. A leader in earthquake engineering, he has done extensive research nationally and internationally in seismology. Archuleta summed up his success by saying, "Start off in a good place that is nurturing, and be ready for what comes." (Courtesy of the Archuleta family.)

Two

WINTON
A TRUE MELTING POT

WINTON. In 1917, in response to the increased market for coal, the Megeath Coal Company opened new mines on the western ridge of Baxter Basin, 14 miles north of Rock Springs, at an elevation of 7,000 feet. In May 1921, the UPCC purchased the mining property and renamed it Winton. Winton had three mines—No. 1, 3, and 7 1/2—and a population between 500 and 700. (Courtesy of CCR.)

A CAMP WAS ESTABLISHED, 1920s. The first steps the UPCC took to make Winton livable included constructing homes, a store, an amusement hall, and mine buildings. A schoolhouse was constructed on the hill to the right overlooking the town. Houses were built on both sides of the main street as well as on the No. 1 hill and to the left of the school. (Courtesy of CCR.)

VIEW FROM THE BOTTOM, 1930s. The camp was topped by three large water tanks, looking much like candles on a cake, that supplied the camp with water. Various houses were below the No. 1 hill, separated from the lower half by railroad tracks and filled coal cars. The rows of houses in the lower half of camp were divided by the main street. (Courtesy of CCR.)

BEHIND THE HOUSES ON MAIN STREET, EARLY 1930S. Some of the houses abutted the creek bed, and behind them were old garages, shacks, and outhouses. Many of the houses had added porches, and coal sheds were close by. The tall building across the street was the boardinghouse, which at one time housed miners of at least eight different nationalities who could not speak English but got along well. (Courtesy of CCR.)

MODERNIZATION. When water was piped to the homes and indoor plumbing became a reality, camp residents enjoyed a better standard of living. Water also allowed residents to establish gardens with yards and fences, which gave homes an improved appearance. Beginning in 1925, when the UPCC repainted the houses, it chose different colors so that homes had some individuality and were more pleasing to residents from foreign countries, where brighter colors were more appealing. (Courtesy of SCHM.)

EPICENTER OF WINTON, 1940. The main buildings were located at the north end of camp. From left to right are the Show Hall, the Pool Hall (William Russell, manager), the post office, and the UPCC store building. To the right are the mine office and the doctor's office (not shown). Above are the superintendent's home, the Community Club House (the building with three windows), and the bathhouse. The bridge and path in the foreground led to the school. (Courtesy of CCR.)

COMPANY STORE, 1930s. Residents depended on the store for most of their daily needs, since Rock Springs was too far away for more than a weekly or monthly trip. J.H. Messenger and J.A. Williams, early store managers, went on buying trips to Chicago and St. Louis with other UPCC store managers to purchase goods for the store. (Courtesy of CCR.)

ROW OF HOMES IN EARLY WINTON (MEGEATH), EARLY 1920s. Most of the early homes in Winton were of a wooden box design with a center drop for a light bulb in each room. They were of similar beige-brown color and had green roofs—a noticeable contrast against the barren area, which had no vegetation. (Courtesy of CCR.)

HOME DESTROYED BY FIRE. In 1930, the home owned by Kalle Keinonen and his wife, Fannie, was destroyed by fire. Fannie Keinonen was badly burned, and few of the house furnishings were saved. The fire was started from cleaning clothes with gasoline. Houses were built so close together in a row that other residents were lucky not to have lost their homes as well. (Courtesy of Dudley Gardner and Western Wyoming College.)

WATER BARRELS IN EARLY WINTON. Mrs. Guy Thomas (left), Mrs. William Kinyon, and their children stand outside the Thomas home. Lily Kinyon is in the center, and Mildred Kinyon is on the right wearing a hat. The other two are unidentified Thomas children. Note the water barrels and washtub by the house. Before a water system was in place, water was shipped from Green River in railroad tank cars and distributed by wagon into barrels at each home. In winter, the water froze, and it was warm in summer; sometimes the tank cars did not arrive at all. (Courtesy of CCR.)

IMPROVING THE WATER SYSTEM. In 1924, the UPCC worked for six months to install pipelines to service the entire camp, spending about $100,000 in an effort to bring in water from an artesian well located west of camp. Miners worked on the project during slow production time in the mines. Here, Frank Franch and his son Gene haul pipe. (Courtesy of the Franch family.)

IN FRONT OF THE PUMP HOUSE. In 1926, these children happily posed before the pump house, a part of the newly created water system. Pictured here are, from left to right, Pearl Antrobus, Alice Hanks, George Stevens, Francis Stevens, Stella Lund, Betty Hanks, Bill Hanks, June Kaul, Lloyd Hanks, Lavone Kaul, and Mary Jane Hanks. (Courtesy of Mickey Kaul.)

LONG-AWAITED BATHHOUSE. On November 1, 1926, the bathhouse was put into operation. The main room for the men had 30 showers and 300 clothesbaskets. The women's bath had six showers and six booths, and the boys' bathroom had three showers. Winton camp residents were most appreciative of the new bathing facilities, as they no longer had to wait for Saturday night and the tin tub. (Courtesy of SCHM.)

OVERLOOKING THE CAMP, 1930s. Harry Lunn used gardening knowledge learned in his native England in trying to duplicate those gardens in a very rocky Winton. According to Lunn, "persistence was his secret" as he won several Garden Contests after he came to Winton in 1925. The Lunn home had a good view of the school (on the hill), the boardinghouse (below the track), and the filled coal cars on the tracks. (Courtesy of CCR.)

PRIZE-WINNING GARDEN. Albert and Martha Gunther stand amongst flowers and vegetables in the beautiful garden that won them third place in the 1936 Garden Contest. The gardens were judged in mid-August, when gardens were in their prime. It was difficult for judges to pick a winner and amazing to see the wide variety of flowers and vegetables that could be grown. (Courtesy of SCHM.)

HOME OF A MASTER GARDENER. In the above 1930s photograph, Frank and May Franch, their daughters Jane and Nila, and Mrs. Franch's mother, Mary Ellen Yarger, stand in front of the Franch home. Frank, an immigrant from Cloz, Italy, was the stable boss but performed many other jobs for the UPCC. His real passion, however, was gardening. He turned a rocky knoll into a beautiful garden, complete with a lily pond, pictured below in 1934. The pond was once filled with fish, but when winter arrived, Frank had to keep the fish in barrels in the basement, so he filled the pond with flowers the next year. Children always loved and remembered the beautiful pond, the remnants of which still exist today! Considering the rocky hillsides in Winton, it was amazing that such beauty could be developed. The Franch family was awarded many prizes for their beautiful flowers and vegetables. (Both, courtesy of the Franch family.)

WINTON SUPERINTENDENT TOM FOSTER. Tom Foster came to Winton in 1925 after serving as superintendent in Reliance since 1921. Above, Foster (center, marked with an X) is shown with unidentified UPCC officials as they survey the Winton mining properties. Foster and his wife, Maggie, were very involved in the activities of Winton and raising five children. Tom Foster served on the School District No. 7 Board of Trustees. When the Fosters left Winton in 1935, they were entertained with a large dancing and card party and presented with a set of Community Plate silver from the camp in appreciation of their neighborliness. (Both, courtesy of Margo Clark.)

MINING TRAGEDY. Marilla and Segundo Caller immigrated to Winton from Santander, Spain, in 1921. In 1930, Segundo was killed in a mine accident, leaving five children behind—Mary, 11 (front left); Joe, 8 (front right); Louie, 13 (back left); Isabel, 15 (back right); and Richard, who was born three months later. Marilla got a job cleaning the mine office two days a week for $40 a month, and welfare provided butter and cheese. The Callers were one of the last families to leave Winton. (Courtesy of Joe Caller.)

SLOVENIAN FAMILY. Many immigrant families moved from one coal camp to another as camps closed. Born in Yugoslavia, John and Mary Ruby (seated) came to Winton from Cumberland. John Ruby was transferred to Winton by the UPCC in 1930, and the family lived there until 1949. The Ruby children—Leonard (left), Margaret, and Albin Vercic—all graduated from Winton Junior High and Reliance High School. (Courtesy of Helen Chadey.)

47

THREE WINTON SONS. From left to right, Mike (born in Yugoslavia), Nick, and John Zakovich were the sons of Helen Lemich. Mike became the owner of Zak's Motors when Nash cars were "the pattern of cars to come." Mike married superintendent Tom Foster's daughter, "Rusty." Nick married Sophia Galovich in 1935 in a typical old-country wedding (pictured below) at the Orthodox church, officiated by Rev. Harold Swezy of the Episcopal church. Many guests assembled for the wedding picture and reception at the home of the groom's parents, Louie and Helen Lemich, in Winton. In 1944, while working as a unit foreman in the No. 1 mine, Nick was fatally injured in a mine accident. John married Oretha Bunning and was a law officer for 40 years—29 years with the Rock Springs Police Department, followed by three terms as Sweetwater County sheriff. (Both, courtesy of Margo Clark.)

Two Generations of Winton Residents. Annie Tardoni, daughter of Mr. and Mrs. Frank Tardoni, was born in Reliance in 1914. She attended school in Winton and married Joe Kragovich (right) in Rock Springs in 1931. Kragovich was born in Colorado and attended school in Winton, working for the UPCC from 1928 to 1954. Joe and Annie Kragovich's daughter, Josephine (below), was wed to John Tarufelli, a miner in the Stansbury mines, at the South Side Catholic Church on June 21, 1952. Annie Kragovich and Josephine's grandmother, Mrs. Frank Tardoni, honored the newlyweds at a dinner in the Winton Community Hall after the ceremony. Grandfather Frank Tardoni, who was born in France, came to the United States in 1906, and the family lived in Winton for over 30 years. Like many others, they were forced to leave Winton at the end of 1952. (Both, courtesy of the John Tarufelli family.)

PECOLAR FAMILY. Anna Pecolar (seated), daughter of Mr. and Mrs. Mike Pecolar, and Ben Dona (left), son of Mr. and Mrs. John Dona, wed in 1935. Both fathers were Winton miners and immigrants—John Dona was from Austria, and Mike Pecolar was from Czechoslovakia. During the Depression, Ben Dona left school to work in the mines, where he eventually became a night foreman in the No. 7 1/2 mine. He participated in first-aid activities from his early youth through adulthood and instructed youth teams as an adult. The Donas were very active in the social activities of Winton. Below, Mike Pecolar kneels beside his grandson, Ray. Mike Pecolar's son, Ray Sr., was a motorman for the UPCC; other family members also made Winton their home and mining their livelihood. (Both, courtesy of Ray Pecolar.)

OLD-TIME WINTON RESIDENTS. The Lemich family lived in Winton for 31 years. Pictured here are Helen Lemich and her son George (left), who served in the military police and was awarded the Purple Heart and Bronze Star. Son Emil (right) served in the Navy. The Lemich family was well known for the large dinners they hosted for Serbian Christmas (January 7), St. George's Day, and Serbian Orthodox Easter. (Courtesy of Margo Clark.)

SERVICEMEN VISITED BY ADMIRAL. From left to right, Winton miners and former servicemen A. Gregory, B. Shalata, L. Caller, H. Griffin, P. Kure, N. Korich, J. Kure, C. Rudelich, W. Lemmon, and G. Lemmon were honored with a special visit from Rear Adm. Joel T. Boone (center) and Comdr. John H. Blalch (third from left). (Courtesy of CCR.)

WINTON WARRIORS. From left to right, Albin Vercic, Nick Korich, Joe Aguilar, and Tony Tomich joined the service to defend their country. These men returned from the war, but their friends and neighbors John Cristando, Melvin Groutage, Tommy Kragovich, Wilfred Marceau, and Bert Tait made the ultimate sacrifice. (Courtesy of CCR.)

OWNER OF THE POOL HALL. William and Elizabeth Russell came from England and lived in Winton for 33 years. "Bill" Russell owned the Pool Hall and came to know many of the camp's young people very well, often giving them advice—and sometimes a dollar or two. As the mines closed, the Russells had to close the Pool Hall and, sadly, leave "the old camp." (Courtesy of CCR.)

MULES, HORSES, AND STABLES. Pictured here in the 1920s are the horse stable and mining operations in Winton. Horses and mules were used before automation, and a stable boss was hired as the animals' caretaker. The animals became accustomed to their handlers—when one Greek miner changed jobs, his mule refused to work for another miner because the animal did not understand English. (Courtesy of CCR.)

DUTCH AND THE WINTON TIPPLE. Facing the tipple in the 1940s is Dutch, the last horse to work in the Winton mines. Dutch was well known to the camp children, as was a favorite old grey mare named Kate. The horses were taken care of by barn boss Frank Franch. (Courtesy of the Franch family.)

WINTON TIPPLE IN MIDWINTER, 1940s. With an elevation of 7,000 feet, winter often visited for long periods, leaving the camp covered with snow. However, snow did not deter the operation of the mines, as railroad cars sat on the tracks waiting for the coal cars to come through the tunnel and be filled at the tipple. (Courtesy of CCR.)

MINE NO. 1. This is the tunnel and slope of Mine No. 1. This mine was unique in that it was the only mine that had a tunnel through which coal was transported from the mine to the tipple. The tunnel opening was near the bathhouse. The box between the two indicated the number of days the men worked without an accident. (Courtesy of Ray Pecolar.)

SAFEST COAL MINE. In 1947, the US Bureau of Mines Safety Award was presented to 80 miners of the Winton No. 1 and 7 1/2 mines for having the best safety record in the 23-year history of the competition. General manager I.N. Bayless stated: "I salute the Winton people, not forgetting that the women and children at Winton contributed their share to this record." The safety supervisors responsible for contributing to this award pictured below are, from left to right, (first row) V.O. Murray (general manager), Frank Peternell (safety engineer), Bill Greek (ventilation engineer), and Ben Dona (night foreman, No. 7 1/2 mine); (second row) William Wilkes (Winton mine superintendent), John B. Hughes (general superintendent), Lawrence Welsh (foreman, No. 1 mine), Enoch Sims (night foreman, No. 1 mine), and Andrew Spence (foreman, No. 7 1/2 mine). (Both, courtesy of CCR.)

FOLLOWING IN FATHER'S FOOTSTEPS, 1945. Most parents did not want their children to work in the mine. However, this young man, Bobby Spence, would meet his father, mine foreman Andrew "Ding" Spence, at the bathhouse and don his mine clothing for the walk home. When he left the camps, Bobby became a dentist—not a miner. (Courtesy of CCR.)

WOMAN DOES HER PART. Mary Jane Miller was described in the UPCC *Employee Magazine* as "an all-around 'man' who deserved praise and admiration." Miller was employed as a slate picker in 1942 and later learned how to operate the tipple. She often double-shifted and worked during holidays. She definitely did her part for the war effort. (Courtesy of CCR.)

UPCC's Tallest Drum Major. Harold Morgan, age 28 in this picture, was well known in Boy Scouts and first-aid activities for his six-foot, seven-inch stature and for his splendid bearing as the drum major for the UPCC bands. In 1940, Morgan suffocated from gas fumes encountered when fire broke out in the 7 1/2 seam of the No. 1 mine. Sabotage was originally suspected as the cause of the fire. Morgan's death affected the entire UPCC community. (Courtesy of SCHM.)

Baseball in Winton, 1931. For the younger men, baseball was a summer diversion. They played on the Winton Dry Lake baseball field against such teams as the "Slavs of Rock Springs" and the "Nipponese." Pictured here are, from left to right, (first row) Nick Jelaco, Clyde Daniels, John Jelaco, Ray Pecolar, and Nick Kragovich; (second row) Tom Clark, Glen Sprowell, Richard Gregory, "Sleepy" Thomas, manager Mike Pecolar, Sid Thomas, Jimmy Moon, and Paul Kragovich. (Courtesy of Ray Pecolar.)

WINTON BADGERS. The winning 1930 first-aid team included, from left to right, Betty Hanks, Josephine Brack, Lindy Lehto, Jessie Aguilar, Evelyn Jolly, Vaun Slaughter, and Muriel Crawford. Their instructors were Pearl Jolly and Andrew Strannigan. Because of this early first-aid training experience, most of these girls later enrolled in nurses' training. (Courtesy of CCR.)

MEN'S TEAM WINS SECOND. In the 1936 first-aid competition, the Winton men's team placed second among nine teams, and each member received $20. Team members included John Wilkie, James Wilson, Bert Peterson, Thomas Edwards, John Nesbit, and John Hawks. UPCC president Eugene McAuliffe praised the men for their fine appearance and for the good work they were doing to promote safety throughout the mines. (Courtesy of Dudley Gardner and Western Wyoming College.)

WINNING FIRST-AID TEAM, 1940. The first-place Silver Cup winners—from left to right, Jayne Wilson, Mary Besso, Margaret Strannigan, Gwen McTee (captain), Joyce Wilkes, and Mary Jane Hanks—put their first-aid skills to work on November 28, 1940. The miners' bus returning to Rock Springs was in an accident south of Winton, and 27 men required medical attention for bruises, arterial bleeding, shock, and other injuries. These Girl Scouts came upon the accident when they were returning from school in Reliance and administered first-aid until doctors arrived. Their efforts were very much appreciated by the miners. (Courtesy of CCR.)

OH, HAPPY DAY! From left to right, Carolyn Jenkins, Wilma Rose Lowe (captain), Sharla Clark, Elizabeth Jean Strannigan, Nila Franch, and Jane Franch were elated after winning first place as the 1952 Senior Girl Scout first-aid team. Thomas Jenkins was their instructor, and Elsie Jenkins was their chaperone. Each team member won a two-piece luggage set. (Courtesy of Dudley Gardner and Western Wyoming College.)

STATE PRESIDENT VISITS. Mrs. Guy Gay, the president of the Wyoming Federated Women's Club, visited the Winton Community Club House. The new building, completed in 1928, had a Spanish-style exterior with French doors out to a balcony covered with a striped canopy. The shiny white kitchen, fireplace, window seats, hardwood floors for dancing, and large room offered residents a place to enjoy camaraderie, cultural growth, community spirit, and fun. (Courtesy of SCHM.)

WINTON GIRL SCOUT TROOP NO. 9. Camp women offered their time and talents to the Girl Scouts in 1946. Pictured here are Beverly Welsh at the piano and, from left to right, (first row) Wilma Rose Lowe, Elizabeth Jean Strannigan, Joanne Marie Jackson, Janet Vaineo, Genevieve Lowe, and JoAnne Vaineo; (second row) troop leader Mrs. Robert Nesbit, Wilma Bollinger, Micky Galloway, LaRee Greenhalgh, and assistant leader Mrs. Albert Volsic. (Courtesy of SCHM.)

April 1 Celebration. April 1 was the holiday to commemorate the UMWA Eight-Hour Day. Elaborate celebrations were held, such as this one in Winton. Miners and their families enjoyed parades, boxing matches, races, picnics, free picture shows at the Rialto, "union-made candy" for the children, and speeches and dances for the adults; schools and businesses were closed for the day. (Courtesy of CCR.)

Enjoying Halloween, 1946. From left to right, Franklin Oliver, Martha and Margaret Plemel, Carolyn Thomas, Dorothy Doss, and Judy Griffin participate—along with 250 parents and children—in the Halloween party at the Show Hall. The evening started with cartoons and a feature film, followed by the grand march. Blanche Welsh and her orchestra played as the children paraded around before the judges; this was followed by a dance for the older children. (Courtesy of SCHM.)

WINTON SHOW HALL. The Winton Show Hall was famous for its beautiful Christmas decorations and programs. Above, in 1926, the community council arranged for a huge tree, an impressive program, and band music. Santa visited and gave bags of goodies to the band members and children. Below, in 1937, one would have had to travel miles to see a more beautifully decorated hall. A 20-foot Christmas tree was magnificent with lights and tinsel, and a large electric sign spelling "Merry Christmas," made by teacher Mr. Curry, extended across the stage. Monk-cloth curtains, used for the first time, were made by Reliance High School girls. The Christmas operetta, *Santa's Air Line*, included 145 pupils, and residents filled the hall to overflowing. Following the play, Santa appeared, and children received a treat of candy, nuts, fruit, and a coin. The school, community council, UMWA, and monthly men (foremen, supervisors, and others on monthly salaries rather than hourly wages) made the treats possible. (Both, courtesy of CCR.)

YOUTHFUL CAMP MUSICIANS, 1928. The Wintonians—from left to right, Evelyn Jolly, piano; Toivo Keinonen, saxophone and violin; Harold Scanlin, trumpet; Rudy Menghini, director; Bobby Dodds, saxophone; and Marion Grindle, drums—performed both in Winton and out of town. They carried their own stage and props and entertained with theatrical acts, performing popular and old-time ballads, dancing, and singing. Billy Spence and Hero Matsumato were also members. (Courtesy of CCR.)

HOMEGROWN PIPER, 1930s. Glenroy Wallace, in Highland costume with the beautiful bagpipes made by his father, was a member of McAuliffe's Kiltie band. His father was the pipe major. An outstanding young man in the community, Wallace graduated from Reliance High School as valedictorian and attended the University of Nebraska, receiving a doctor of dental surgery degree. He also served as a captain in the Army Dental Corps at Mather Air Field. (Courtesy of CCR.)

WINTON TAMBURITZA BAND. Tamburitza bands originated in Eastern Europe and consisted of a variety of stringed instruments from the Balkan countries. In the 1940s, this group studied under John Brueggeman, playing polkas and folk music in bars and at dances. Emil Lemich played first brac (far left), George Lemich played bass, Jack Krmpotich played bugaria, Nick Painovich played brac (far right), and Bob Zigich (seated), leader and main singer, played mandolin. (Courtesy of Joe Caller.)

BEHIND THE OUTHOUSE, 1945. Camp musicians started at an early age and were encouraged to play a variety of instruments. This country-and-western duo consisted of "Cowboy" Bobby Spence (left) and "Country Boy" Tommy Hughes (right). If the music was too loud or not good, only those in the privies could complain. (Courtesy of CCR.)

A Home for the Catholic Faith. St. Ann's Catholic Church served the faithful for nearly 30 years. Many residents attended the bimonthly masses, sent their children to catechism, and watched as they took First Communion there. St. Catherine's Altar Society was very active in the community, meeting at homes and the clubhouse. The Reverend S.A. Welsh of Rock Springs conducted services at Winton for almost 30 years. A young man, Larry Welsh (right), who took his First Communion at St. Ann's, became a bishop in Spokane and later St. Paul and Minneapolis. Appointed by Pope John Paul II in 1978, he said his first mass, assisted by Msgr. Albin Gnidovec, in Rock Springs in 1962. His parents were Mary and Lawrence Welsh, longtime Winton residents. (Above, courtesy of CCR; right, courtesy of Lawrence Welsh family.)

SUNDAY SCHOOL. Since there was no church at Winton, William Kinyon started a Union Sunday school. He served as superintendent and Mary Ila Antrobus Kaul was the pianist. The UPCC provided a building, and 50 children were enrolled by 1926. (Courtesy of SCHM.)

SCHOOL IN FULL SWING. The Winton School was located at the top of the hill, across from the store. Students walked across a bridge and up a seemingly long path to reach it. The UPCC initially rented the school to School District No. 7 for $1. In 1925, four swings and a slide were installed, to the delight of the children. The school closed in 1954. (Courtesy of CCR.)

FIRST-GRADE STUDENTS, 1926–1927. These students were children of early miners in the camps of Winton (Megeath). School supplies were meager, and teachers had to be creative. A PTA was organized and donated two water fountains and two bookcases, and it collected books for the library. Miss Graefe was the principal. (Courtesy of CCR.)

SCHOOLMARMS. May Yarger and Vendla Huhtala were two popular young teachers in 1926. Their signed contracts, for $125 a month, included keeping the schoolhouse in good repair, providing fuel and supplies, and janitorial work. Yarger married barn boss Frank Franch, and Huhtala married mine foreman "Ding" Spence. (Courtesy of CCR.)

DANCING DOLLS. These young schoolgirls were dressed up for a performance in the school program "Pageant of the Dolls," which was held at the Winton Show Hall on December 16, 1927. Costumes for a variety of performers were handmade by teachers and parents, and songs and dances were created and choreographed by the teachers. The orchestra, led by Mr. Post, earned applause from an extremely supportive audience. (Courtesy of CCR.)

SECOND YEAR FOR WINTON PUPILS. These students posed outside of the school in 1931. Verle Slaughter (marked with an "X" in the front row) died in August 1932 from peritonitis following an appendectomy. Slaughter was born in Winton on May 9, 1925, and had lived there all her life; she was popular among her school- and playmates. (Courtesy of Henry W. Telck family.)

JUNIOR HIGH. During the 1931–1932 school year, these eighth-grade students graduated from Winton, after which they were bused to Reliance to finish their education. Teacher Thomas Seivert handed out awards for perfect attendance, citizenship, and outstanding school effort. Superintendent Clyde Kurtz presented the diplomas. Afterward, a school picnic was held at the Winton Cedars. Races were run and ballgames were played, and ice cream cones were given to all. (Courtesy of CCR.)

SIXTH-GRADE STUDENTS, 1940. These students had been learning lyrics, as indicated by the songs on the blackboard; "Little Sir Echo" and "Roll Out the Barrel" were favorites. Lucille Lampman was employed as the music supervisor for the entire district, so music was taught along with the "three Rs." (Courtesy of the Franch family.)

GRADE-SCHOOL TEACHERS, EARLY 1950s. Children in the camps were fortunate to have quality teachers. Pictured here are, from left to right, teachers Pauline Lanoy (fifth grade), Joan Duzik (second grade), Shirley Marlett (fourth grade), H.M. Lamer (fifth and sixth grades), Dorothy Lamer (third grade), and Mary Angeli (first grade). (Courtesy of CCR.)

CLASS OF 1957 IN FOURTH GRADE. Pictured here in 1948–1949 are, from left to right, (first row) Sidney Curle, Mary Jane Nesbit, Jimmy McMillan, Jimmy While, Lewis Starrett, and Shirley Peterson; (second row) Freddie Wall, RoseMarie Rudelich, Bobby Spence, Archie and Kenneth Robinson, Viola A., and Jimmy Peterson; (third row) teacher Shirley Marlatt, Vivian Arguello, Joanne Guerri, and Carol Evanoff. (Courtesy of CCR.)

NOTHING LEFT. After the mines closed in 1952, the dismantling of a wonderful camp and the displacement of people and memories began. The Winton store, which anchored the community, provided most of life's necessities, and was the recipient of most of the miners' paychecks, was sold piece by piece. On June 13, 1954, Fr. S.A. Welsh said the last mass. The post office officially closed on January 31, 1955. (Courtesy of CCR.)

WINTON IN 1956. There would never be another place like Winton, which was so close to the hearts of those who lived there. This tiny community, nestled in the hills amid sagebrush, rocks, and cedar trees, vanished and returned to a ghostlike state. Winton, Wyoming, was no more, but the memories and friendships would remain. (Courtesy of CCR.)

MOVING ON DOWN THE ROAD. One by one, favorite buildings and homes were sold and moved to other places. This building, the Community Club House, which had been the scene of many parties, showers, Sunday school, scout meetings, and women's activities, became the new home of the Fort Bridger American Legion. (Courtesy of CCR.)

THIS WAY TO WINTON. Russ and Wanda Ferguson Slaughter, who lived in Winton and were married there in 1937, stand in front of the road sign showing the way to Winton. No matter where Winton residents went after the camp closed, the sign to Winton always meant the way home. (Courtesy of George Spence.)

Three

DINES
A COLONY COAL COMPANY CAMP

DINES. Dines, located 12 miles northeast of Rock Springs, opened around 1918 and closed in the early 1950s. It was not a UPCC camp but rather was owned by Colony Coal Company (CCC) and named for the family of Tyson Dines, one of the original owners. The mine produced some of the highest-grade coal in the country. The camp had about 100 homes, boardinghouses for single men, company buildings, and a school. (Courtesy of CCR.)

A WORK IN PROGRESS. Though it was advertised as a model city in Sweetwater County, the early mining conditions and housing in Dines did not really bear witness to that statement. However, this picture shows several buildings—a hotel that was not really used, rooming houses, and a union hall—that did appear well built. This seemed more like a typical Western mining camp than a model city. In time, it changed into a community. (Courtesy of the Stimson Collection.)

IN THE BEGINNING. With increased demand for coal, and in competition with the UPCC mines, the Colony Coal Company of Denver opened Dines. Owners George W. Harris, Peter Holme, and Tyson Dines Jr. incorporated the coal company in 1918 with capital stock of $1 million and terms of the corporation's existence set for 20 years. The company officially dissolved in 1957. (Courtesy of SCHM.)

Mining Crew. On a very cold morning in 1936, these workers, with their lunch pails and headlamps, were ready to go into the mine. Working side by side, these miners of many nationalities and races had names like Silva, Sikich, Succo, Coleltti, Bucho, Mazzolini, Crouch, Turner, Bell, Pinter, Colombo, Kloviska, Navarro, Menapace, Courtier, Samuels, Woodsmall, Varras, Peters, Petrovich, Lawrence, Slaughter, Bryson, Jackman, Markisich, and Moore. (Courtesy of Maxine Menapace Jereb.)

Down in the Mine. Compared to the deaths occurring in the UPCC coal mines, the Dines mine was relatively safe. However, these miners were working in an area with a loose roof, and the falling top coal caused Caesar Colombo's death in 1943. A native of Italy, Colombo had lived in Dines for 20 years. Leslie Sharber, Sweetwater County's "first colored draftee," according to the local paper, was also killed by falling coal in 1949; he had spent 14 years in Dines. (Courtesy of CCR.)

DINES MINE. The mines became electrically equipped, with most of the high-grade coal cut by mining machines. The "Dines Mine" shack served as the dummy shack. During World War II, Esther Nelson and Florence Smith replaced male miners, filling sacks with sand in this shack. Before explosives were detonated in the mine, the sacks were put into holes drilled in the coal. (Courtesy of CCR.)

HEADED FOR THE TIPPLE. Filled coal cars left the mine and headed for the tipple, where the coal was sorted for transport. With increased demand for coal, production at the Dines mine also increased. The tipple, trestle, and tracks, although wooden, seemed to be very well constructed and were quite an imposing view within the camp. (Courtesy of the Stimson Collection.)

LARGEST TIPPLE. Colony Coal constructed a large wooden tipple—the biggest one in the Southwestern mining district at the time. It was equipped with a modern screening plant, which helped avoid coal breakage. Many children cut across the tracks as they went from one side of Dines to the store and post office on the other side. Luckily, no one was ever injured by a moving railcar. (Courtesy of the Stimson Collection.)

COAL LEAVING FOR MARKET. Railroad cars of high-quality coal, leaving Dines through the middle of town, were on the way to distant commercial markets. Dines coal was highly sought-after because of the manner in which it was mined and prepared. Because Dines was underlain with coal and production assured for a long time, Colony Coal was extremely competitive with the UPCC mines. (Courtesy of the Stimson Collection.)

Two Camps in One. Dines was comprised of North and South Dines. The business section, a boardinghouse, and homes were located in North Dines. The elementary school was at the top of the hill dividing the two parts of camp. South Dines had another boardinghouse and several homes, some of which were homes to black families. While housing was somewhat segregated, there was no segregation otherwise within the camp. (Courtesy of the Stimson Collection.)

South Dines. It appeared that houses were scattered in the prairie with no apparent design in mind. The company, however, felt that if the homes were not built in rows (as was typical in other camps), they would be less susceptible to fire if one house began to burn—thus the noticeable disorganization. (Courtesy of SCHM.)

BUILDING A CAMP. Hugh Crouch (center) and friends Tommy (left) and Jess work on camp projects in the 1920s. Housekeeping in Dines was not easy, as they had to make do with available furniture from the store and powder boxes for cabinets. Houses were poorly made, and water had to be carried from a cistern. (Courtesy of the Crouch family.)

HOUSING IN DINES. Between 100 and 150 homes were scattered on the hills of Dines, renting for $10 to $15 a month in the early days. Most were four rooms, and residents were required to perform upkeep, with the company providing paint. Coal (for heating purposes) had to be purchased from the company. Before there were water lines, residents had to haul water, and there were ubiquitous tales of the wells being full of rats. (Courtesy of CCR.)

HOUSE NO. 436 IN SOUTH DINES. Carlo and Giustina Piaia emigrated from Italy—he in 1906 and she in 1910. They initially lived in Reliance, where Carlo helped construct some of the rock buildings and where they began their family. Later, they moved to Dines, where Carlo was a blacksmith. Their children were Elda, Carla, Clara, Dolores, Dante, Carlo, and Roland. The children excelled in school—Dante was the 1941 salutatorian—and were musically talented. Elda and Carla served as Dines's postmistresses. In South Dines, the Piaias lived among several black families; race was not a barrier, and they fished, hunted, and became good neighbors and lifelong friends. The house below was a typical home in South Dines. (Both, courtesy of Charlene Menapace Kershisnik.)

BUSINESS DISTRICT. The photograph of North Dines shows, in the foreground, the Amusement Hall (with the teacherage in the top), where most of the community activities took place—movies, dances, card parties, showers, school programs, first-aid instruction, and the wonderful Christmas festivities. Next is the Pool Hall, which was off-limits to camp children but available for miners to have a beer and play pool. Directly below is the company store, where miners and their families could charge and use scrip to pay for purchases. Directly to the right of the store is the CCC office building. (Courtesy of CCR.)

CATCHING UP. Enjoying some conversation in front of the Dines store on a summer day in 1945 are, from left to right, Irene Thompson, an Ornelos child, Mary Zagnolio, Carla Menapace, and the Reverend B.G. Rodda. Menapace was the postmistress, and Rodda was a Nazarene pastor who lived in Dines for more than 16 years. During that time, he presided at many camp weddings and Reliance High School graduations. (Courtesy of Charlene Menapace Kershisnik.)

CCC Headquarters. This building housed the camp offices of Colony Coal. In 1926, the president of the company was G.W. Harris, who had his office in Denver. The general manager was B.A. Harris, and his assistant was G.C. Davis, who was in charge of the mine operations. Herbert Tomlinson was general foreman, Oscar Cappa was top foreman, Robert Grout was master mechanic, Park Allison was mining engineer, George Haldeman was chief engineer, and A.E. Pollard was the company doctor. (Courtesy of the Stimson Collection.)

Colony Coal Employees. A Colony Coal employee and supervisor stand in front of the Dines Mine Office. Colony Coal Company business, payroll, and store billings were handled in the office. It was a popular place for miners, as they lined up at the office window to get cash advances in the form of scrip, which could only be used at the company store and Pool Hall. (Courtesy of CCR.)

FIRST SCHOOL IN DINES. In 1922, the first camp school opened in South Dines. The Boundary Board required the Colony Coal Company to provide for a school. Judging by the appearance of some of the children's clothing, the miners and their families faced hard times. Some of the children spoke English, while others did not, and there were a variety of educational levels. (Courtesy of Maxine Menapace Jereb.)

SCHOOL IN 1924. By 1924, classes were divided into upper and lower grades. This was an upper-grade class of fourth through sixth graders, and the only one identified is Annie Samac (first row, second from right). (Courtesy of Carmen Stephens Thomas.)

NEW BUILDING. By 1926, School District No. 7 had grade schools in every camp. This building was owned by Colony Coal Company but rented to the district for $1 per year until the district purchased it through a bond issue. There were two rooms on the main floor, with one housing grades one through three and another four through six, and the upper-level rooms were unused. The teachers during the 1930s were Ruth Graham and Katherine Vehar. (Courtesy of CCR.)

WPA PROJECT. The elementary school was on rocky ground at the top of a hill reached from North Dines by steep steps. In 1934, through Works Progress Administration projects, the school grounds were leveled, a retaining wall was built to hold the dirt, and the pathway to the school was widened. There were rocks and caves west of the school that students played on and in during recess; many carved their initials in the rocks for posterity. (Courtesy of SCHM.)

Picture with the Superintendent. Clyde Kurtz became superintendent of School District No. 7 in 1933. He monitored the schools in the district, attempting to make all the schools comparable. In the Dines school, new blackboards were added and cloth curtains were made by the high school home economics students to replace the crepe paper and art projects on the windows. It was hoped that this would help reduce direct sunlight and improve eyesight. (Courtesy of Charlene Menapace Kershisnik.)

Line Up. Schools were the focal point for camps, and this group of young students (dog included) lined up outside the Dines School in 1945 for an activity. They may have been about to watch the Music Week play *Harmony Hotel* or attend a program sponsored by the PTA. (Courtesy of CCR.)

PICTURE DAY. Students in the combined grades had their pictures taken on the steps of the Dines school. The class included children from the Piaia, LaSalle, Oleffe, Brunner, Colombo, Shepard, Toodles, Kilburn, Fletcher, Courtier, Stenins, and Spence families. In 1952, there were eight students left in the school. In 1954, the school in Dines closed. (Courtesy of Audrey Brunner Caller.)

CAMP DOCTOR'S FAMILY. Mary McDill, daughter of Dr. and Mrs. Wilson McDill, is shown with her children in the family's yard. Dr. McDill was the physician in Dines for a number of years during the 1930s. His office was in the back of his home, and Mrs. McDill served as his nurse. When they left in 1939, the community presented the doctor with a medical kit and Mrs. McDill with handkerchiefs. (Courtesy of Maxine Menapace Jereb.)

THE CROUCH FAMILY. One of the well-known families in Dines was the Hugh and Elizabeth Crouch family. On his way to Washington, Hugh Crouch came to Dines to visit a friend and ended up staying. He met his wife in Dines, and they were married in 1926. The Crouch family consisted of eight children—Estelle, Arthur, Leonard, Hugh Jr., LeRoy, John, Bob, and Sara. Some of them went to college, some worked in the coal mines but then went on to the trona plants, one became a minister, and all became good citizens. The word "segregation" meant little in Dines. As Elizabeth Crouch said, "the only thing separating the town was the hill which divided Dines into North and South." Pictured below are Sara and friend Esther Mazzolini. (Both, courtesy of the Crouch family.)

ANOTHER SOUTH DINES FAMILY. In 1930, the Gresham family included Walter (who came from Alabama), his wife, Louise (who came from Kansas), and their children (from left to right) Thomas, Jeannine, Ramona, and Walter Jr. Harvey, Julius, and David were born after this picture was taken. The Greshams lived in house No. 100; the children attended school in Dines and Reliance. (Courtesy of the Crouch family.)

A SON OF DINES. One of the young children of Dines was Ronnie Succo, shown playing in the yard of his home. He was the grandson of Carlo and Katie Menapace and died in a plane crash in the 1980s. This image depicts the typical yard around Dines homes—no fenced yards, flowers, or trees; it had more of a desert landscape than the other camps. (Courtesy of Maxine Menapace Jereb.)

WEDDING BELLS. An elegant wedding took place in 1937 when Helen Yakimovich became the bride of Robert Colombo, son of Caesar and Mary Colombo of Dines. Andrew, John, and Verna Yakimovich and Josephine Colombo were attendants. Anne Yovich and Madeline Gagliardi were flower girls, and George Fech was the trainbearer. Helen Yakimovich was employed at Woolworth, and Robert Colombo by CCC; they made their home at Dines. (Courtesy of Anne Yovich Robertson.)

TWO AUDREYS FROM DINES. Audrey Spence (left), daughter of "Scotty" and Cassie Spence, moved to Dines in 1929. A 1942 RHS graduate, Spence played the piano for many school and community activities. Audrey Brunner (right) was a 1941 RHS graduate and the daughter of Mr. and Mrs. John Brunner. Stepping out of Uncle Sam's hat, Brunner was crowned "Miss America" at her patriotic senior class hop. (Courtesy of Audrey Brunner Caller.)

FROM MINER TO LIEUTENANT GENERAL. James L. Spence was born and raised in the coal camps and graduated from Reliance High School in 1940. An Army veteran of World War II and the Korean War, he joined the National Guard in 1950, becoming a major general in 1977. In 1988, Wyoming governor Ed Herschler awarded Spence his final star as a lieutenant general. Spence worked in the mines at Dines and as a Union Pacific brakeman. (Courtesy of CCR.)

EDUCATOR FROM THE CAMPS. Estelle Crouch lived in Dines for her entire childhood, graduating from Reliance High School in 1943. She was a role model for black women of that time, as she left the camps and earned a bachelor's degree in education from Kansas State Teacher College and a master's of science from the University of Wisconsin. She retired in 1990 from the Denver school system. (Courtesy of the Crouch family.)

LAW MAN. George "Mac" Nimmo graduated from Reliance High School in 1943, the University of Wyoming in 1950, and the FBI Academy in Washington, DC. He spent his life in law enforcement, beginning with the military police in the Army and serving as a deputy sheriff for Rock Springs, Sweetwater County undersheriff, Sweetwater County sheriff (for 12 years), and the director of the Wyoming Law Enforcement Academy. He was also the president of the Wyoming Peace Officer's Association. (Courtesy of SCHM.)

CITY OF ROCK SPRINGS. Cipy Cordova graduated from Reliance High School in 1951. He was in a Navy flight squadron and was a flight engineer in the Air Force for 37 years. The Air Force had eight of the above planes based in Cheyenne and named them all after Wyoming cities. Cipy flew Lt. Gen. Jim Spence, Ernie Mecca (General Spence's aide), and Gov. Ed Herschler in the *City of Rock Springs*, their favorite plane. (Courtesy of Cipy Cordova.)

END OF AN ERA. When the need for coal diminished in the early 1950s, Colony Coal Company began disbanding the Dines community, bringing an end to an era for the people who had made their home and living there. The CCC offered several buildings for sale: a large three-story frame building with oak floors and bath for $1,500, a 24-by-24-foot two-story building for $250, a 30-by-80-foot two-story building for $750, and a 29-by-40-foot two-story building for $350, as well as a central heating plant. (Courtesy of CCR.)

THE LAST TO GO. One of the last Dines residents, Paul Nelson, remained to sell the buildings and houses. Many went to Rock Springs and Kemmerer. Nothing much remained of this camp in the desert hillsides except the memories of those who lived there. Despite poor living conditions, residents of many nationalities remembered how everyone treated each other equally and helped each other as necessity required and how lifelong friendships were formed. (Courtesy of CCR.)

Four

STANSBURY
THE NEW MINE ON THE BLOCK

STANSBURY. Stansbury, located nine miles north of Rock Springs, was named for Capt. Howard Stansbury, who discovered the rich coal beds. The mine opened during World War II to meet increased demand for coal. It was the last UPCC mine to open (in 1944) and the last to close (in 1957). The camp consisted of modern homes, a school, and several community and mine buildings. At peak employment, there were 1,000 miners working three shifts in the mechanized mines. (Courtesy of CCR.)

MODERN HOUSING. Unlike the other camps, Stansbury was built on flat ground instead of the Wyoming hillsides. With government assistance, rows of homes were quickly built. The superintendent's home was a six-room house, five others were five-room homes with dining rooms and garages, and six were four-room, semi-modern houses with garages. They had basements and indoor plumbing and were white (except for the superintendent's home). The houses were heated with coal, which was stored in bins in the basement. Housewives had to hose down the bins or the black dust soon covered the house walls. A ton of coal cost $20, and homes rented for $40 per month. The water supply was taken from the Reliance water well. Automatic streetlights were a welcome addition in 1945. (Both, courtesy of CCR.)

A House Is Not a Home until It Is Planted. As soon as houses were constructed, the UPCC provided trees and fertilizer for residents to begin planting yards. Within five years, there were 500 trees planted in the camp. This pristine home with a well-landscaped yard belonged to Robert Bollinger (pictured), who won first place in the 1943 Garden Contest. (Courtesy of SCHM.)

Happiness Grows with Radishes and Roses. Mrs. Baca stands in front of her bountiful garden of vegetables and flowers. The UPCC encouraged families to keep vegetable gardens to augment meals when the miners were not working a full week or when they went on strike. The company even provided professional advice for those who wished to plant gardens. (Courtesy of SCHM.)

BOARDINGHOUSE. Stansbury was a boom camp in 1945 when Jim and Ann Cummings came to operate the boardinghouse. Ann Cummings's mother, Kata Krpan, had run a boardinghouse in Reliance. The house boarded 50 men and the overflow from two homes across the street, but all of the miners and carpenters ate at the boardinghouse. Shift workers required two breakfasts—one for those coming from work and the other for those going to work—and the packing of two sets of buckets. Amazingly, the Cummings family's meals were always on time, no one left hungry, and the occasional visitor was always welcomed. The Cummings family served as the unofficial hosts of Stansbury, finding time to prepare dinners and sponsor parties for the camp and groups from Reliance High School. They were extremely gracious, generous, and hospitable to everyone. (Both, courtesy of SCHM.)

UPCC Store, Community Hall, and Post Office. This complex was the social center for camp activities. The store opened for business at 9:30 a.m. on March 9, 1946. Housewives were at the doors waiting to purchase hard-to-get items like soap flakes, towels, sheets, overalls, women's hose, and chewing gum. Louis Milojevich was the first manager, and William Menghini was the butcher. The community hall opened its doors on March 16. A dance was held, and the hall was filled to capacity. George Okano furnished the music, and Ann Cummings prepared food. The post office opened on March 29, 1946, with Mrs. Tony Rudelich as its first postmistress. The ladies at the counter wait for the customers coming into the newly stocked store. (Above, courtesy of Melvin Sharp; below, courtesy of SCHM.)

STRIKES AND SPARES. Bowling took Stansbury by storm. Both alleys were busy every night with bowlers of all ages. A married women's league was organized, and every Sunday evening was reserved for mixed doubles. The Boy Scouts used the lanes on Wednesday nights. League results were posted in the UPCC magazine. (Courtesy of SCHM.)

ONE-STOP SERVICE. The community building provided many amenities for residents. Along with bowling, pool tables, and dancing, one could utilize the services of a barber while the rest of the family enjoyed something from the fountain or purchased the latest magazine. Ann Cummings stands behind the counter. (Courtesy of SCHM.)

OPENING OF SCHOOL. District 7 schools opened for the 1945–1946 school year in September, with Ira Russell serving as superintendent. Junior high students were transported to the Reliance schools from Winton, Dines, and Stansbury, but classes for grades one through six were held in the outlying camps. Teachers for the new Stansbury School were Zoe Lee (first and second grades), Ruth Lacey (third and fourth grades), and Kathryn Hurley (fifth and sixth grades). (Courtesy of Melvin Sharp.)

FUTURE TENNIS STARS, 1946. Under Paul Johnson and Lois Collins, directors of the School District No. 7 recreation program, young people learned to play tennis, utilizing the new court by the school. Pictured here are, from left to right, (first row) Joe Baca, James Palcher, and Billy Lewis; (second row) Billy Hanley, Jimmy Mecca, John Maffoni, Melvin Sharp, Peggy Sharp, Lois Mecca, Joanne Eccli, and Bill Palcher. (Courtesy of SCHM.)

STANSBURY MINE OFFICE. Superintendent Melvin A. Sharp was responsible for the construction and development of the Stansbury mining operations. His private office was located at the new mine office. This mine office served many purposes, housing an engineer's office, a general meeting room, an emergency first-aid room, and the ambulance garage. (Courtesy of Melvin Sharp.)

STANSBURY "BOSSES." In 1947, these supervisors and foremen kept the Stansbury mine operating. Pictured here are, from left to right, (first row) James Mecca, James Law, Frank Lebar, Raino Matson, and George Della; (second row) John Marushack, Ernest Besso, G.A. Neal, John Nesbit, Ernest McTee, and Hodge Burress. All of these men had extensive mining experience in the various coal camps. (Courtesy of CCR.)

BATHHOUSE BUILDING. The tile and concrete bathhouse contained a change room, a gang shower room, a lamp room, and a mine foreman's office and was designed to accommodate at least 500 miners. A board containing the miners' check number tags was kept in the bathhouse. When the miners returned from their shift, they placed the ID tags on the board. A supervisor checked to make sure everyone was accounted for before he went home. (Courtesy of Melvin Sharp.)

CLOTHES-HANGING SYSTEM. When the men went to work, they exchanged their regular clothes for mine clothing at the bathhouse. A hanging basket system was used to lift their clothes, towels, and personal items toward the ceiling until they finished their shifts. After their shifts were over, they returned their "pit" clothes to the ceiling in the same manner and showered off the coal and rock dust. (Courtesy of Melvin Sharp.)

STANSBURY TIPPLE. The new steel tipple was built by Allen & Garcia of Chicago, the same firm that built the Reliance tipple. Coal reached the tipple from the main haulage tunnel over a double track surface motor haul of 13,100 feet. The tipple had a loading capacity of 500 tons per hour. In 1956, the UPCC purchased a rescreening plant from Colony Coal Company to improve the grade of coal loaded. (Courtesy of Dudley Gardner and Western Wyoming College.)

MAGNIFICENT SIGHT. After the announcement of the opening of the Stansbury mine in 1942, this coal car was eagerly anticipated. UP 85745 was the first car of coal loaded from the new Stansbury mine in March 1943. It contained 59.95 tons of coal that would be used for transporting war materials. (Courtesy of CCR.)

MASTER ELECTRICIAN. Bill Lewis was a lifetime resident of the mining communities and an important employee for the Stansbury mines who kept the electrical operations functioning. Lewis and his family were involved members of the community, and his son Billy was the 1955 valedictorian at Reliance High School. When the mines closed, the family moved to West Virginia, where Lewis accepted a position with Truax-Traer Coal Company. (Courtesy of SCHM.)

TAKING A BREAK. From left to right, Igy Mlinar, Bill Greek, and Tom Overy relax in the miners' break room. These men were very involved in the first-aid and safety programs, participating on first-aid teams and instructing others. Note the tools of the safety trade—the pick and safety lamps. (Courtesy of Ray Overy.)

ACTIVE UNION MAN. Frank Burlech began working in the mines when he was 14 years old, earning $1 a day. He worked as a hoist man in the Stansbury mines and was a very involved member of the UMWA, chairing many April 1 Eight-Hour Day and Labor Day committees. (Courtesy of SCHM.)

ANOTHER LOAD OF COAL. In the depths of the mine, Adolph Porenta, machine runner, and Ernest Boyer, machine helper (left), shovel "bug dust," or fine coal dust. This photograph was taken in 1946 in the Reliance No. 7 mine. Even though Stansbury was a mechanized mine, manual labor was sometimes a necessity. (Courtesy of SCHM.)

SAFETY MEN. Henry "Pinkie" Welsh (left) and Harold Clark stand in front of the rock tunnel leading to the Stansbury mines in 1953. They had just completed an inspection of Mine No. 3 with the mine foreman, Ernest Besso. Welsh was president of the Stansbury United Mine Workers Local No. 8078. (Courtesy of CCR.)

THE WHISTLE BLEW. November 10, 1955, was a fateful day for mine foreman John Nesbit (right) and miner George Chenchar; the roof of Mine No. 7 caved in as the load crew was leaving the face. Three other miners were recovered. The accident left an indelible impression within the camp community, as Nesbit was an experienced miner who was very involved in safety and first aid. He was survived by a wife and three children. (Courtesy of CCR.)

JUNIOR GIRL SCOUT TEAM, 1945. Even though Stansbury was just evolving, the community immediately began Scouting and first-aid programs. This first-place team includes, from left to right, (first row) Joanne Cummings, Lois Mecca, and Patricia Brown; (second row) Carol Matson, Avis Williams, and captain Peggy Sharp. The girls each won a camera. (Courtesy of SCHM.)

WINNING FIRST-AID TEAM, 1956. This team was working on a First Aid Contest problem that required treatment of wounds on the face and each arm, a fractured foot and ribs, and a dislocated hip. Team members included LeGrand Wardle, Primo Gatti, Jack Collins, Alfred Brown, Andrew Spence (captain), and Tom Overy. Each team member won $40. (Courtesy of Dudley Gardner and Western Wyoming College.)

THE MAFFONIS. John Maffoni, born in Palagano, Italy, immigrated in 1921. He worked in the Kansas coal mines, for Ford Motor Company, and in the mines in Walsenburg, Colorado. He married Mary Chiesi on February 14, 1926, and moved to Winton in 1941, then to Stansbury. While in Winton, Mary Maffoni worked with Gala Griffin in the boardinghouse. They left Stansbury when the mines closed and returned to Walsenburg for retirement. (Courtesy of John Maffoni.)

"MEACH." John Maffoni Jr. was an outstanding athlete at Reliance High School, receiving All-Conference and All-State honors. Upon graduation in 1952, he attended the University of Wyoming, where he played football for the Wyoming Cowboys and was named "Top Man of the Week" for his defensive play. He became a high school teacher and administrator. (Courtesy of John Maffoni.)

TRANSPLANTED. The Williamson family—from left to right, Brenda, Bob, Patricia, and Barbara—came from Russellville, Arkansas, where their father, A.D., worked in the mines for $20 to $30 a month. In the early 1940s, Williamson heard about the Stansbury mine, which offered employment and better wages. In the middle of winter, he moved his family to Stansbury house No. 81. A.D. was one of the first to run a continuous miner in the Stansbury mines. (Courtesy of the Williamson family.)

OLD OUTDOOR PRIVY. Stansbury had indoor plumbing, but James Mecca (right) and his 1952 classmates decided to try the outhouse for a new experience—they didn't read the sign and got into the "ladies' room" of the two-seater. (Courtesy of CCR.)

STANSBURY GIRL CROWNED QUEEN. Marilyn Nesbit, whose father was killed in the 1955 cave-in at Stansbury, is crowned queen of the 1957 junior prom by Bill Thomas. Her attendants were Joan Nichols (left), whose father was in the same accident, and Leona Thienpont (right). Patty Pirnar was the crown bearer. "April Love," "Love Letters in the Sand," and all of Elvis's songs were favorites of the evening. (Courtesy of CCR.)

CAMP GIRL BECOMES RN. Carol Kalinowski was salutatorian of the 1954 Reliance High School class and a 1958 graduate of the University of Wyoming. Her parents, Victor and Gertrude Kalinowski, were longtime coal camp residents; Victor began his mining career in Winton before coming to Stansbury. Her grandparents, Clement and Mary Elizabeth Bird, were immigrants from England and arrived in Winton in 1921. (Courtesy of CCR.)

MINER, ENTREPRENEUR, POLITICIAN. After working as a miner in Raton, New Mexico, Louis Tomassi moved to Stansbury when the mines opened, becoming a miner, then manager of the Stansbury UPCC store. With an accordion purchased from Sartoris' School of Music, he also became the camp musician. When the mines closed, and with only an eighth-grade education, he started several successful businesses—a supper club, a motel, a bowling alley, and a car dealership—in the Kemmerer and Big Piney areas. He was also a two-term county commissioner and a five-term Wyoming state legislator. When Stansbury was closing in 1957, Tomassi gave notice that he was closing the store. He played at the last gathering of the Stansbury residents as they sang, danced, and reminisced about the last 15 years. The final party and the closing of the store unofficially marked Stansbury's closing for the residents of the community. (Left, courtesy of Lillian Pryich; below, courtesy of CCR.)

NOTICE

I am closing the Stansbury store. All merchandise in stock will be sold to the general public at wholesale prices.

Closeout sale will start Monday, March 11, and continue to April 1.

Drive Out to Stansbury and Save!

ALL SALES FINAL
NO REFUNDS, NO EXCHANGES

LOUIS TOMASSI

Five

RELIANCE HIGH SCHOOL
THE TIES THAT BIND

UNITED WE STAND. Reliance High School, designed by UPCC engineer James Libby, was built in 1926. The gymnasium was completed in 1930. After the mines closed, the high school also closed (in 1959), and students were bused to Rock Springs. Not only did the school provide for the educational needs of high school students from the four coal camps in School District No. 7, it also served as the tie that unified the camps. (Courtesy of CCR.)

A NEW HIGH SCHOOL. A bond issue was passed for a new centralized high school. It was not ready when the issue passed in 1925, so classes were held in the Bungalow until Reliance High School finally opened its doors to 30 freshmen and 20 sophomores. The classes included such names as Robertson, Kelley, Pinter, Spence, Sturholm, Mattonen, Kovach, Anselmi, Ruotsala, Fisk, Furhrer, Oberger, Lawrence, Telck, Keinonen, and Hanks. Principal Leo Hanna (second row, far left) stood with the group in 1927. (Courtesy of CCR.)

BEGINNING A TRADITION. On September 27, 1929, the freshman class endured the first Reliance High School initiation. Girls had to don men's hats, socks, and shoes and turn their clothes inside out. Boys had to put on makeup and hair ribbons and wear flapper dresses. The faculty—as well as the upperclassmen—appreciated the group's sportsmanship as they paraded through the school. (Courtesy of the Henry W. Telck family.)

FIRST BASKETBALL TEAM. On March 23, 1930, from left to right, Reliance Pirates Menhart Pinter, Bill Spence, Alfred Richmond, Ray Mattonen, Ed Ruotsala, Gasper Krek, and Guido Anselmi boarded the "Tournament Special" bound for Laramie to participate in the 13th annual basketball tournament held by the University of Wyoming. Coached by O.C. Rogers, Reliance was eliminated with a 16-13 loss to Baggs. (Courtesy of CCR.)

RELIANCE BEATS ROCK SPRINGS 29-19. In 1946, classes were cancelled in Reliance when this basketball team beat Rock Springs for the first time in 20 years. Rock Springs coach Bert Melchar faulted the "cracker-box" Reliance gym for the loss. Pictured here are, from left to right, coach Jack Smith, Richard Borzago, Jack Mullens, Emil Lemich, Tom Burns, and Kenneth Delgado; (second row) Mike Kouris, Jack Nimmo, Frank Tatman, George Varras, and Bill Connor; (third row) Robert Matson, Doral Wilde, and Rudy Delgado. (Courtesy of CCR.)

113

CINDERELLA TEAM OF 1949. Coach Jack Smith's Reliance Pirates beat the Worland team, the Cheyenne Indians coached by legend Okie Blanchard, and the Lusk team to have the opportunity to play the Casper Mustangs for the state championship. Unable to cope with the Mustangs' height and manpower, the Pirates captured second place. Spiro Varras was the first Reliance player named All-State. Despite the loss, the Pirates wrote their own chapter in Wyoming basketball history. With an enrollment of 105 students, barely qualifying them to play Class A basketball, and the tallest player only 5 feet 11 inches tall, their performance was brilliant. Pictured above are, from left to right, John Fortuna, manager Henry Telck, and Michael Fresques; (second row) assistant coach Tom Manatos, Everett Hernandez, Spiro Varras, Bill Strannigan, and coach Jack Smith; (third row) Stanley Kouris, George "Bud" Nelson, Ernie Mecca, George Jelaco, and Jack Rafferty. Of this group, six became teachers, administrators, or coaches of championship teams. People from all the camps followed and supported the team with enthusiasm and pride. (Both, courtesy of CCR.)

114

First Six-Man Football Team, 1938–1939. Pictured here are, from left to right, (first row) Fred Kallas, Nick Chakakis, George Lemich, Jim Zelenka, Nick Zagaris, George Mangelos, and Mike Simvoulakis; (second row) Charlie Rudelich, Yutaka Hattori, Andy Korogi, Junior Brack, Pete Grohar, Donald Clark, and Steve Simvoulakis; (third row) Ray Wilkes, Louis Groutage, Ralph Bencoach, Allen Easton, John Krek, and Tommy Kragovich; (fourth row) coach C.V. Irvin, John Kure, James Spence, Jack Nelson, Joe Tardoni, and assistant coach and superintendent Clyde Kurtz. (Courtesy of CCR.)

Runners-Up, 1949. Reliance lost 28-20 to the Byron Eagles at Byron in the state championship game. The Pirates were undefeated, and Byron had won 40 straight games. Mike Fresques was the most valuable player. The traveling squad included Mike Fresques, Bud Nelson, Stanley Kouris, Tony Tsakakis, Jim Rafferty, George Jelaco, Bill Strannigan, Ernest Mecca, Frank Shifrar, Alex Spence, Bob Miller, Ronald Wilson, Robert Burns, Walter Sawick, Jimmy Mecca, Richard Bergandi, and Cipy Cordova. The team was coached by Jack Smith and Tom Manatos. (Courtesy of CCR.)

LETTERMAN'S CLUB. Because of the success of the athletic teams, a letterman's club was formed in 1945. Various topics were discussed at the meetings, and it was the school's attempt to make good citizens out of good athletes. The club paid for the seniors' sweaters through pop and candy sales. White sweaters were only worn by those who had played on a championship team. Coach Jack Smith sponsored this group of well-dressed gentlemen in the 1950s. (Courtesy of CCR.)

PIRATES' BOOTY. Robert Auld, senior class president when Reliance High School closed in 1959, stands before the trophy case in the upper hall of the school. The case housed many trophies and awards earned by RHS teams. With each trophy came great memories and wonderful stories of athletic achievement. (Courtesy of CCR.)

TRAVELING IN STYLE. In 1949, not only did the Reliance Pirates rank first or second, leading the Southwest Class A Conference, they also led the conference in traveling comfort. The Pirate squad used the 1949 14-passenger bus above to travel to away games. The car was equipped with a two-speaker radio purchased with money from bake sales held by the Lettermen's Club, two heaters, and comfortable seats. In contrast, teams of the later 1950s—not as successful as their predecessors—were relegated to riding in the "milk wagon" bus below. It was functional but not classy, and there were several harrowing experiences as teams traveled in it during the winter. A winter trip coming home from Jackson through Snake River Canyon when the bus went over the edge of the canyon was one of those experiences. (Both, courtesy of CCR.)

HOMECOMING PIRATE AND PRINCESS. RHS inaugurated its first homecoming celebration in 1940 with a parade and snake dance through the main part of town that ended in a rally around a huge bonfire, where speeches, yells, and singing were presented on the eve of the "battle." Royalty was crowned. In 1953, Clayton Brown and Beverly Coet were crowned king and queen, and George Gutierrez (left) and Norma Jean Kragovich (right) were attendants. (Courtesy of CCR.)

HAIL, HAIL, THE GANG'S ALL HERE. In 1942, many high school girls participated in pep club. They cheered at all the basketball games, performed entertaining drills during halftime, and added to the atmosphere of the game. This group of girls was close-knit and enjoyed social events as well as pep club activities. In 1942, the squad sponsor was Sophia Tranas (first row, far right). (Courtesy of Maxine Menapace Jereb.)

ROOTING FOR THE PIRATES. Being a cheerleader in 1954 meant being able to wear maroon corduroy uniforms with white blouses and saddle shoes for all of the basketball games. Pictured here are, from left to right, Carolyn Jenkins, Sharon Rollins, Norma Jean Kragovich, and Dorothy Williams. (Courtesy of CCR.)

1945–1946 RELIANCE HIGH SCHOOL BAND. The camps had many wonderful musicians, and parents encouraged their children to play in community bands as well as the high school band. The high school uniforms were very militaristic, with maroon jackets and white pants with maroon stripes. The hats were interesting but did not fit all heads well. Lucille Maxwell was the music teacher. (Courtesy of CCR.)

AND THE BAND PLAYED ON. M.A. Nyquist became the RHS musical director in 1947. He had just returned from overseas, where he served as a Red Cross field director during the war. In 1950, Nyquist directed one of the finest groups of musicians in the area. Under his masterful guidance, band members received superior ratings at attended music festivals and were asked to perform at many community functions. (Courtesy of CCR.)

HONORARY MUSIC. Members of the high school student body who participated and excelled in music were included in the Honorary Music group. This 1950 group included, from left to right, (first row) Donna Gibbs, Jane Nelson, Shirley Kalinowski, Frances Korogi, Marilyn Nyquist, Audrey Sims, and sponsor M.A. Nyquist; (second row) Bill Strannigan, Ronald Wilson, Ernest Fresques, Franklin Shifrar, J.R. While, Larry Welsh, Art Nyquist, and Dick Gibbs. (Courtesy of CCR.)

LADIES' NIGHT OUT. Male members of the band performed *Betty Blight's Style Show* at an assembly in 1942. "Ladies" of the cast included Mac Nimmo as Betty, plus Ralph Zelenka, John Kovach, Pat Burns, Bill Zelenka, John Gaylord, Tom Hall, Bill Zelenka, Raymond Dupape, Tommy Burns, and Earle Gunderson. They were such a hit that Rock Springs High School invited them to perform at its assembly. (Courtesy of SCHM.)

SHORTNIN' BREAD. The Music and Drama Departments performed this minstrel show in 1955. Old Southern and river songs were sung, musicians played, and audience participation was encouraged. A very entertaining evening was enjoyed by the audience and the participants. (Courtesy of CCR.)

BECOMING A HOMEMAKER. The Home Economics Department and FHA (Future Homemakers of America) were integral parts of Reliance High School. Girls were not only instructed in how to become homemakers, they practiced social skills and etiquette, learning how to entertain at teas and preparing and serving banquets for the school and community. In 1950, Mary Ann Kovach (left) is participating at one of the home ec teas. Girls also learned to sew. At the end of each year, the instructors would coordinate a fashion show. In the waning years of the school, Henry Chadey, the superintendent, purchased bolts of cloth from state surplus for use by the Home Economics Department. In 1958, it was camouflage material, and the girls made curtains for the rooms and dresses for themselves. Gail Clark, Dixie Branstetter, and Jeanne Lucero are pictured from left to right below modeling their individual creations. (Both, courtesy of CCR.)

LEARNING TO DANCE. No one in the school could escape learning to dance, because dances were one of the main social activities in the community. At right, Gale Greenhalgh and John Vidakovich work to get the steps correct at a 1950 Sweetheart Ball. (Courtesy of CCR.)

PROM ROYALTY. The junior prom was the major event of April 1950. Decorations were in all shades of red, centered on a large red sail with a yellow sunset in the background. Lucille Smith was elected queen by popular vote, with Marilyn Rollins (left) and Rosa Bergandi (right) as attendants. After the crowning, the queen and her escort led the grand march and danced to "Harbor Lights" and "The Tennessee Waltz." (Courtesy of CCR.)

FIRST GRADUATES, 1931. Graduation marked the real beginning of Reliance High School and was a milestone that would be anticipated by students who followed these graduates. This first graduation was a great accomplishment for everyone involved. The students now had a real sense of belonging and would no longer be the "stepchildren" of Rock Springs High School. Superintendent Leo Martin presented graduates Edward Adolph Ruotsala, Verna Veronica Vollack, Tauno Matt Ruotsala, Gasper Peter Krek, Betty Hanks, Sadie B. Auld Edwards, Alfred Martin Richmond, Jessie Marie Aguilar, Raymond Theodore Mattonen, and Blanche Venita Snyder. Ray Mattonen, valedictorian, and Betty Hanks, salutatorian, were presented University of Wyoming scholarships. The first graduating class of Reliance High School had made their mark! (Left, courtesy of CCR; below, courtesy of SCHM.)

THE LAST CLASS. On May 18, 1959, the last commencement exercises at RHS were held for five graduates: from left to right, Kenneth Keelin, (student body president), Veronica Bozner (valedictorian), Robert Auld (salutatorian), Beverly Tabuchi (junior prom queen) and Robert Sawick (athlete). Gov. J.J. Hickey delivered the commencement address. Superintendent Henry F. Chadey presented the class, and Raino Matson, a member of the school board, awarded the diplomas. Only memories of "On Reliance," the Reliance Pirates, and wonderful school days would remain. (Courtesy of CCR.)

END OF A TRADITION. In School District No. 7, it was customary for the children and faculty to enjoy a picnic at the Winton Cedars to mark the end of the year. This group of faculty, staff, and students gathered one last time in 1958, enjoying the opportunity to reminisce about their days at Reliance High School. (Courtesy of CCR.)

ALL-CLASS REUNION. In 1984, former classmates, faculty, school board members, and camp residents returned to attend the School District No. 7 All-Class Reunion. Pictured here are, from left to right, (first row) Tom Jenkins (school board member), Jean Gilpin Peppinger, Regina Black Roettger, and Henry Chadey (chairman of the reunion); (second row) M.A. Nyquist, Marjory Nyquist, Mary Foster Benson, and Edith Rupar; (third row) Jack Smith, Mary Lou Thompson, and Tom Manatos. (Courtesy of CCR.)

SUPERINTENDENT CLOSES THE SCHOOL. Henry F. Chadey, teacher and superintendent at Reliance High School, remained to close the school in 1959. He continued to work on coal camp reunions for former graduates, teachers, and camp people. An excellent photographer, he endeavored to preserve the history of the communities and the schools through his picture collection. (Courtesy of CCR.)

RHS Becomes a Junior College. College president Charles Crandall (left) stands with board members in the front of the new Western Wyoming Junior College in 1960. When the high school was closed in 1959, the building became the first campus of the college. The college remained in Reliance until 1969, utilizing the classrooms, lunchroom, and gymnasium facilities. It was then relocated to a brand new campus in Rock Springs. (Courtesy of CCR.)

Goodbye, Old Friend. Reliance High School served well and unified the coal camps of School District No. 7 for 33 years. In 1989, it was listed in the National Register of Historical Places. During the oil and gas boom in the early 2000s, it was purchased and turned into apartments for gas and oil personnel. This was a sad fate for a wonderful educational institution whose halls were indeed hallowed. (Courtesy of CCR.)

DISCOVER THOUSANDS OF LOCAL HISTORY BOOKS FEATURING MILLIONS OF VINTAGE IMAGES

Arcadia Publishing, the leading local history publisher in the United States, is committed to making history accessible and meaningful through publishing books that celebrate and preserve the heritage of America's people and places.

Find more books like this at
www.arcadiapublishing.com

Search for your hometown history, your old stomping grounds, and even your favorite sports team.

Consistent with our mission to preserve history on a local level, this book was printed in South Carolina on American-made paper and manufactured entirely in the United States. Products carrying the accredited Forest Stewardship Council (FSC) label are printed on 100 percent FSC-certified paper.

MADE IN THE USA